IMAGES
of America

PHILADELPHIA'S CITY HALL

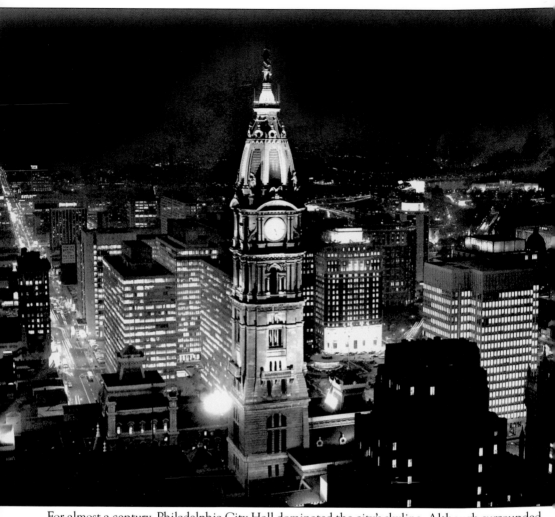

For almost a century, Philadelphia City Hall dominated the city's skyline. Although surrounded by many newer structures over the decades, the 19th-century structure symbolized Center City Philadelphia well into the 1980s.

IMAGES
of America

PHILADELPHIA'S CITY HALL

Allen M. Hornblum and George J. Holmes

ARCADIA
PUBLISHING

Published by Arcadia Publishing
Charleston, South Carolina

Printed in the United States of America

Library of Congress Catalog Card Number: 2003110384

For all general information contact Arcadia Publishing at:
Telephone 843-853-2070
Fax 843-853-0044
E-mail sales@arcadiapublishing.com
For customer service and orders:
Toll-Free 1-888-313-2665

Visit us on the Internet at www.arcadiapublishing.com

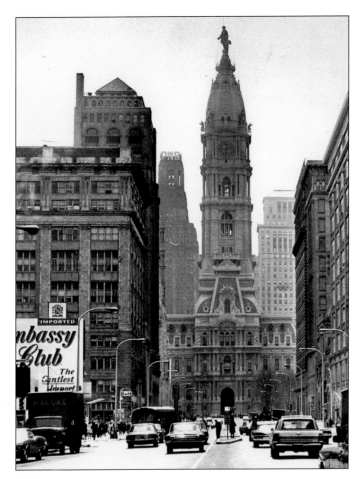

This book is dedicated
to the hardworking
men of Southwark,
Kensington, Northern
Liberties, and other row-
house neighborhoods of
Philadelphia who lost their
lives in the construction of
Philadelphia City Hall.

CONTENTS

ACKNOWLEDGMENTS

This project could not have been accomplished without the assistance of two excellent repositories of Philadelphia history. Both the Philadelphia City Archives and Temple University's Urban Archives allowed us to peruse their enormous photograph collections. The Urban Archives, moreover, supplied us with little known items about the politics, construction, and history of city hall from their extensive newspaper collection that dates back to the 19th century. Particular thanks are due Margaret Jerrido, Brenda Galloway-Wright, and Evan Towle of the Urban Archives for their assistance and friendship.

Special thanks go to Greta Greenberger, the director of the Philadelphia City Hall tours program and arguably the old building's most dedicated and knowledgeable defender. Greenberger and her devoted group of tour guides enthusiastically provide thousands of tourists each year a fact-filled and illuminating history of city hall. When we had a question about the grand old lady of Broad and Market Streets, Greta was the one we turned to. Invariably, she had the answer.

The authors would also like to thank Ronnie Avery and Dot Holmes for their assistance with this project.

INTRODUCTION

Begun shortly after the Civil War and completed at the dawn of the 20th century, Philadelphia City Hall is nothing short of an architectural and sculptural masterpiece. An outdoor art museum to some, a great layered wedding cake to others, the enormous, ornate structure at the intersection of Broad and Market Streets in downtown Philadelphia is regarded by many architectural critics as one of the most impressive municipal government buildings in the world. Historically, artistically, and as the functioning center of local government and judicial activity in the county, Philadelphia City Hall has become a well-known social, political, and physical reference point for generations of tristate residents. Once the tallest and largest working building in America, its exterior façade displays one of the most elaborate and comprehensive packages of allegorical sculpture in the world. City hall's prominence and staying power, however, belie the building's fractious beginnings and controversial history.

Planning for Philadelphia City Hall began long before the first shovel of dirt was cleared from Penn Square in 1871. For decades, certainly since the consolidation of the city in 1854, people recognized the terrible overcrowding at the old, 18th-century city hall at Fifth and Chestnut Streets. Just where the new structure should be located became the contentious question. For decades, opposing camps marshaled their arguments for Independence Square, Washington Square, or Penn Square. Politicians, newspaper editorial writers, businessmen, and average citizens all joined the fray. Finally, in October 1870, a public election was held to decide the issue. The Penn Square site was chosen over Washington Square by a vote of 51,623 to 32,825.

Once that squabble was settled, city decision-makers then moved on to the next series of political hurdles and administrative obstacles. The commonwealth had established a blue ribbon commission to oversee the construction of new public buildings. Issues such as the make-up of the commission, who would receive the contracts to be awarded, whether to construct one or four buildings, and the selection of an architect were just a few of the thorny concerns they had to contend with. None of these divisive issues were resolved easily.

John McArthur Jr., a Scottish architect who came to America in his youth, was selected to design the new building after he had triumphed in several prize-winning competitions. His design incorporated the elaborate Second Empire style that had become the taste of the age. McArthur's design called for one large square building arranged around a central public courtyard. Its four exterior facades were to be similar in appearance and include four monumental arched portals leading to the courtyard from the outside. Mansard-roofed pavilions, deeply sculpted columns, segmental arches, and tautly drawn tiers of dormers were part of the original plan. Curiously, sculpture was largely ignored.

The building commission requested some changes from McArthur, one of which would result in city hall taking on the most ambitious sculptural decorative program of any public building

in the United States up to that time. By the time of its completion 30 years after it had begun, the new public buildings, or city hall, contained 94 sculptured figures and more than 250 figurative works on the exterior and interior of the building.

Undoubtedly, the most famous statue of the many decorating the structure is that of Pennsylvania's founder, William Penn, who is perched atop the building's awesome clock tower 548 feet above street level. The 37-foot metal statue, which was designed by another Scottish immigrant, Alexander Milne Calder, was placed on top of the tower in 1894, more than 20 years after the construction of city hall was begun. The 27-ton figure is said to be the largest statue on top of a building in the world. Originally, McArthur's plan called for the building to be topped by a figure of Justice, but the substitution of a statue of the colony's founder was just one of the many changes that occurred during the long 30-year construction process.

From the very beginning, McArthur intended on city hall reflecting Philadelphia's importance and designed the structure to be the tallest building in the world. Though he missed that singular distinction by just a few years due to the completion of the Eiffel Tower and the Washington Monument, Philadelphia City Hall did hold the title of the tallest occupied building until 1909, when New York built the Metropolitan Life Building. In sheer size, however, McArthur's massive city hall held sway until the mid-1940s, when the Pentagon was finally completed. To this day, city hall is the largest municipal building in North America and quite possibly the world. With nearly 700 rooms housing the offices of the executive, legislative, and judicial branches of government, Philadelphia City Hall has been a fully functioning municipal office building for more than a century.

Modeled after the Palais des Tuileries and the new Louvre in Paris, architect McArthur made sure to incorporate slate mansard roofs, pavilions, dormers, and double columns that enabled the seven-story structure to appear to be three, fitting into his vision of a grand government building. Augmenting the interesting architecture is an allegorical sculptural package that many observers believe is second to none. Initially hired as a plaster modeler, Calder combined a naturalistic bent with the neo-baroque elements of the Beaux-Arts tradition, popular at the time, to inspire forms of foliage, animals, and people that are still admired to this day.

Though many of the sculptural depictions were purely decorative in purpose, most of the emblematic illustrations were meant to give meaning to the structure by expressing the pride Philadelphians had for their past, present, and future contributions to America. Each section of the building was displayed with decorative figures that symbolized the nature of the business that went on there. On city hall's south side, where the courts were located, were sculptural images of Moses and sobering seated figures representing law and liberty.

After more than 100 years, city hall remains relatively unchanged from its original design and construction, a beautiful marble and granite masterpiece whose architecture and sculpture can still be treasured today and for generations to come.

One

THE NEW CITY HALL

From the very beginning, Philadelphia City Hall was steeped in controversy. Debate raged for years regarding the need for a new city hall. Where should it be located? Should it be one or four structures? How much should it cost? Who should be awarded the prize of architect of the new municipal structure? These were just a few of the vexing questions asked by the public. A public election settled the question as to where—a five-acre plot of ground at Broad and Market Streets that had once been called Center Square and had formerly been home to the city's waterworks, and a public gallows before that. Penn Square, as it was called, was not as fashionable as some of the older, more established sections of the city, but people and business were moving westward towards the Schuylkill River, and it was where the colony's founder had always intended city hall to be. The competition for chief architect of the new city hall was won by John McArthur Jr., a Scottish immigrant who had studied architecture with some of the top names in the field, including Thomas Ustick Walter, the architect of the United States Capitol in Washington, D.C. In fact, some of McArthur's early designs resembled the nation's capitol, a fact that did not go unnoticed by Walter, one of the selection committee jurors. Moreover, Walter became a paid assistant to McArthur on the city hall project, thereby helping his former student to produce something far beyond the quality of his previous works, which included prisons, hospitals, and office buildings.

As construction finally began in the early 1870s, McArthur continued to revise his design for the building, each revision contributing to progressively more sculpture on the structure's walls, roofs, and balusters. In this regard, he was probably supported by Samuel C. Perkins, the head of the prestigious building committee, who desired to make city hall the envy of the nation.

The collaborative effort of McArthur, Walter, Perkins, Calder, and William Struthers, the stonemason, was impressive. They sought something more than showcasing local parochial interests or crass symbolism. Though their building adopted the French flair in design that was popular at the time, they wanted the structure to project America's great idealism and heroic national character. Yes, there would be local token bias with mythic Philadelphians such as Penn, Benjamin Franklin, and Horace Binney depicted on the building, but no others would be present. Not even George Washington, Abraham Lincoln, or Ulysses S. Grant, who were wildly popular at the time. Instead, the building would display an amazing selection of Biblical, classical, and freely invented allegorical references.

The construction project itself was nothing short of exhausting; not surprising considering the end result was designed to be the tallest and largest building in the world. Just getting the building materials to the Penn Square site was an exhausting venture. The marble, for example, came from Lee, Massachusetts, and was shipped to Long Island Sound, where it was put on barges and sent down the Delaware and Raritan Canals to Struthers stone-cutting operation on the banks of the Schuylkill River near Locust Street.

During the 19th century, it became increasingly clear that Philadelphia's old city hall was too small and totally impractical for a rapidly growing metropolis that considered itself "the Athens of America." Debate and argumentation lasted for decades as city fathers grappled with questions of where the new city hall should be located, how many buildings should be part of the complex, and how much the project should cost.

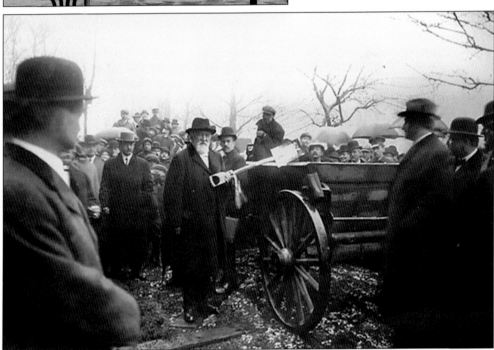

After years of rancorous debate, city fathers along with the New Building Commission finally broke ground for a new city hall in 1871. Penn Square, formally known as Center Square until 1829, was once the site of the city's waterworks; before that, it was a common field that was occasionally used as a site for public executions and numerous "scenes of debauchery, gambling and drunkenness."

Embarked on just a few years after the turmoil of the Civil War, the construction of city hall was a monumental undertaking that consumed the city for several decades. These photographs from the early 1870s show the groundwork being laid for what John McArthur Jr. and building commissioner Samuel C. Perkins expected to be the largest building in the world. In the bottom photograph, the north and south portions of the building can be seen emerging with the courtyard in the middle.

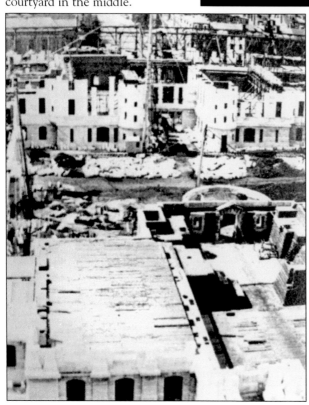

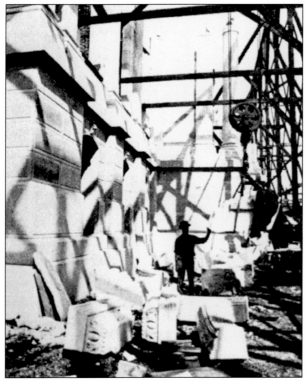

One of the key members of the Scottish contingent working on city hall was William Struthers, the stone and marble contractor. His stone carving operation was based along the Schuylkill River between Chestnut and Locust Streets. Massive blocks of masonry were cut at that location and then hauled to Broad and Market Streets, where they were laboriously lifted into place.

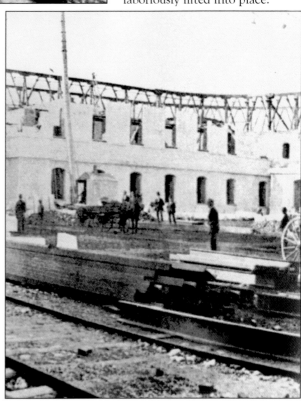

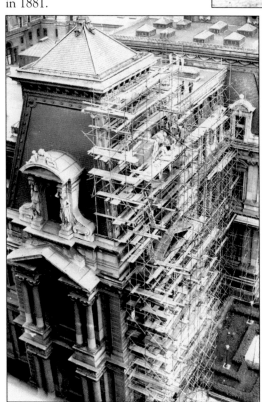

The construction of city hall was a difficult and dangerous undertaking. There were dozens of injuries, and at least 19 laborers lost their lives during the course of the building's construction. Some, like Jacob Durr in 1877, were crushed to death by large stones. Others fell to their deaths, like Peter McDevitt, an employee of the stonemasons Struthers & Sons, who fell from the southwest corner of the building in 1881.

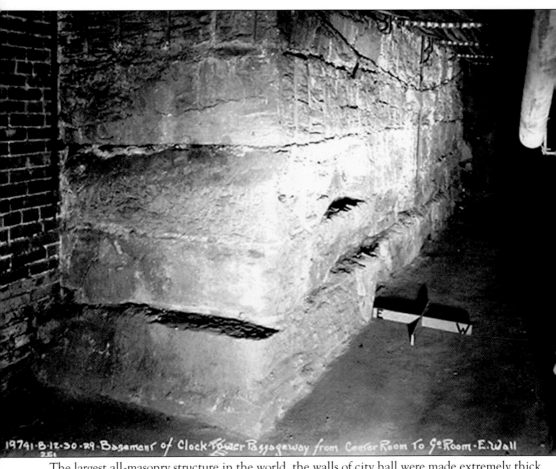

19741·B·12·30·29·Basement of Clock Tower Passageway from Center Room To 9º Room·E·Wall

The largest all-masonry structure in the world, the walls of city hall were made extremely thick to support the building's massive weight. This was especially true at the base of the clock tower. This photograph shows part of the 22-foot-thick walls in the basement of the building. The largest single block of stone was said to weigh 36 tons.

Born in Bladenock, Scotland, in 1823, John McArthur Jr. came to America when he was 13 years old. After training under such renowned architects as Thomas Ustick Walter and William Strickland, McArthur came into his own in the 1850s and 1860s and was chosen as the architect for a new city hall in 1869. Interestingly, Walter was one of the key jurors in the design competition and a crucial assistant during the building's construction.

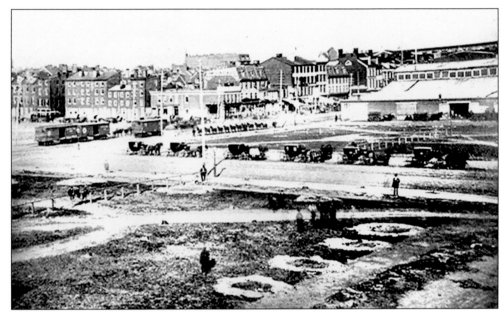

Nearly five acres in size, Penn Square was originally on the outskirts of the city, but by the second half of the 19th century, it was becoming an attractive area of expansion and commercial growth. This photograph shows a corner of the square where McArthur once considered placing one of four municipal buildings prior to his decision to construct one large city hall.

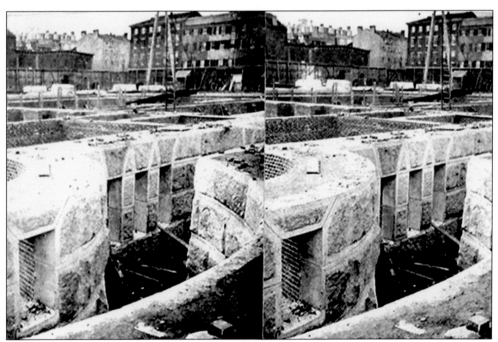

This c. 1870s stereoscope image shows the brick and granite foundation of city hall. Designed without the support of a steel superstructure, millions of hand-carved bricks and huge blocks of granite, many weighing over 30 tons, had to be firmly placed to insure the structural integrity for what was intended to be the tallest building in the world.

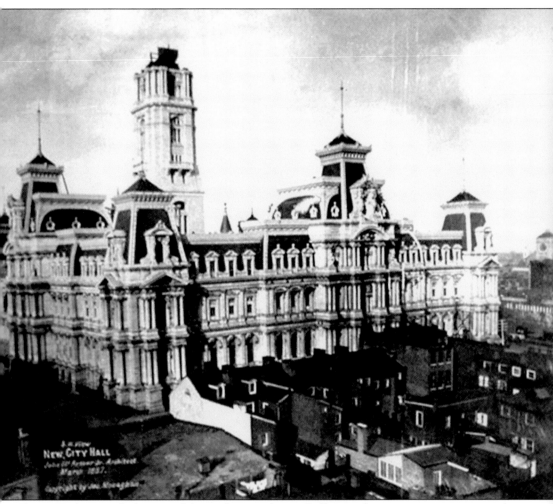

This 1887 photograph shows work being done on the city hall tower. It was seven more years until the statue of Penn was placed atop the tower. Private homes along the south side of city hall have long since been removed and replaced by banks, hotels, and large commercial buildings.

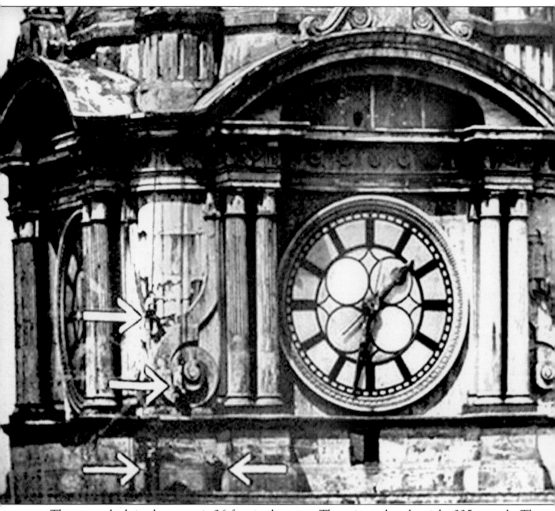

The great clock in the tower is 26 feet in diameter. The minute hand weighs 225 pounds. The clock was originally lit by candles and later by 552 light bulbs. The statues above the clock represent early Swedish settlers who came to the area before Penn. The statues may appear small from ground level, but in fact, are 24 feet tall. The eagle next to them has a 12-foot wingspan.

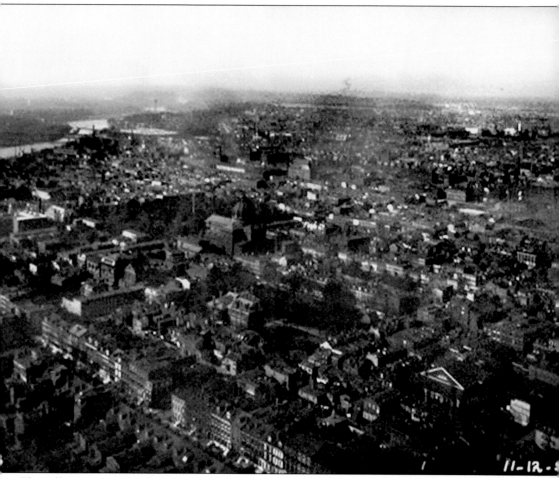

The tallest structure in the city provides a breathtaking panoramic view from Penn's hat. This 1898 photograph shows the northwest section of Center City with the Schuylkill River and the Cathedral-Basilica of Saints Peter and Paul off in the distance to the northwest.

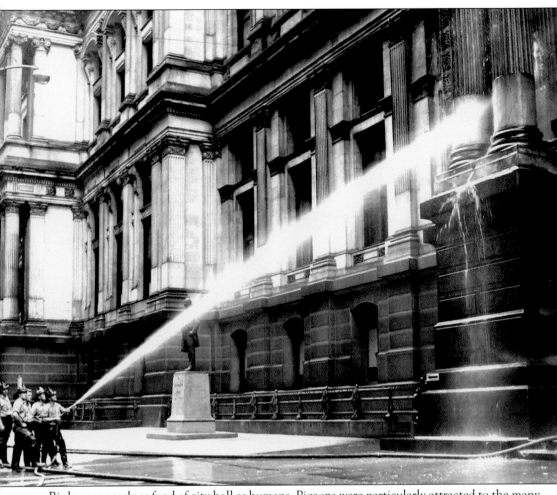

Birds were nearly as fond of city hall as humans. Pigeons were particularly attracted to the many nooks and crannies of the building's ornate architecture. The fire department was periodically called to roost out the structure's winged residents with high-pressure hoses, as this 1953 photograph demonstrates.

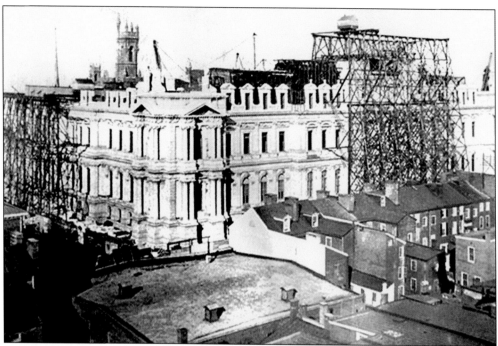

The above photograph shows wooden braces supporting the south and west sides of city hall during construction. The 1891 photograph of the new city hall below demonstrates how completely McArthur's enormous and extravagant piece of masonry dwarfed the surrounding residential structures. Twenty years after construction was completed, the tower was still incomplete, and it was another ten years until architects and builders considered the building finished.

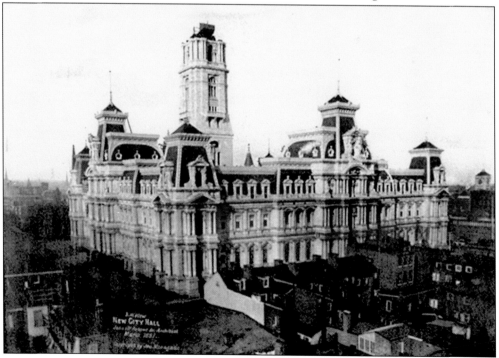

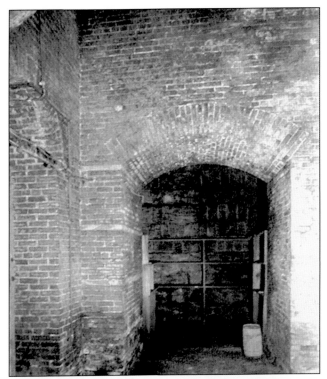

The basement and subbasement of city hall had to be extremely sturdy to support the building's great weight. This was particularly true under the tower, where some walls were 22 feet thick. Hand-carved bricks and massive blocks of imported granite and limestone were vital to the building's solid construction.

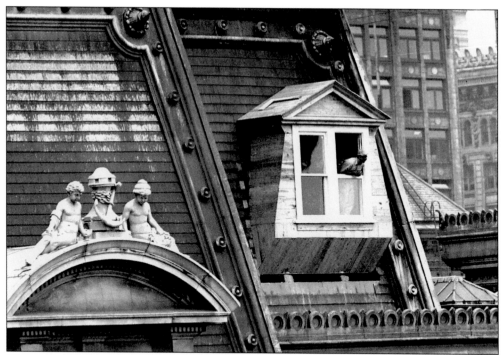

The construction of the Louvre in the 1850s became the taste of the age, and the desired style in America and around the world during the second half of the 19th century. McArthur's prize-winning design of 1869 was French inspired, incorporating the use of mansard roofs, pavilions, and numerous other Louvre-like additions.

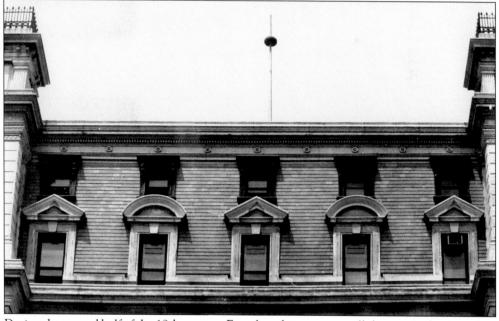

During the second half of the 19th century, French architecture was all the rage in the American architectural community. French-influenced slate mansard roofs, dormers, and pediments were all incorporated into McArthur's architectural plan for Philadelphia City Hall.

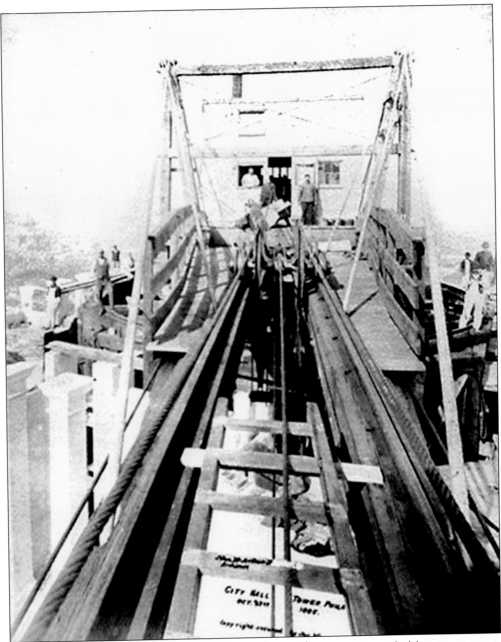

High above Center City Philadelphia, construction workers operate a primitive steam crane. This 1885 photograph shows construction workers at work on the tower, which John McArthur hoped would be the tallest structure in America upon its completion. Unfortunately, even before the tower was completed, the Washington Monument had exceeded the top of Penn's hat.

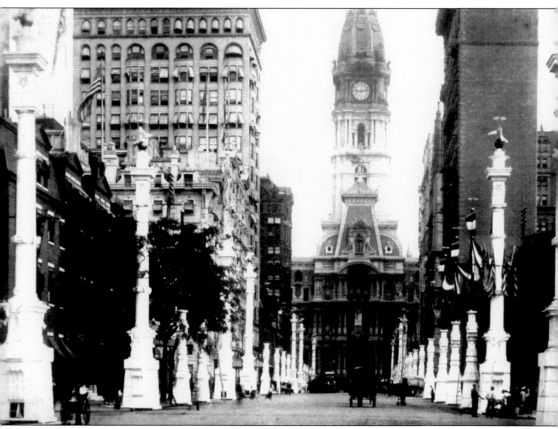

This 1898 photograph with city hall in the background shows the city's efforts to celebrate the culmination of the Spanish-American War. The Peace Jubilee was a major event in Philadelphia, as can be seen by the victorious display of decorations on Broad Street.

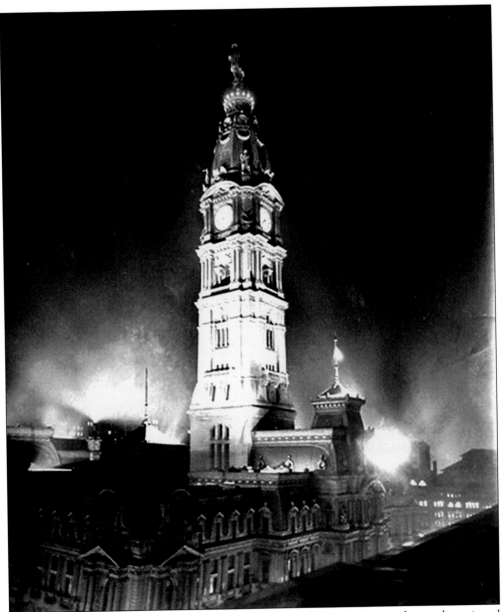

This evening photograph of city hall illustrates the tower's 19th-century grandeur and continued majestic presence. Though it fell short of being the tallest structure in the world, it was for a short time the tallest functioning building in the world. To this day, city hall continues to claim the title of having the largest piece of sculpture on top of a building in the world.

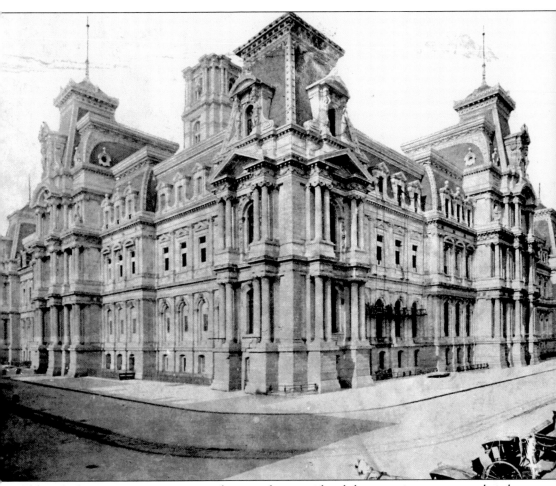

Although there were many writers at the time that considered the emerging structure colossal and stupendous, there were others who were far less charmed by the enormous mass of masonry. One English critic called it a "chamber of horrors" while Alice Reppelier described city hall as a "writhing, struggling, decaying" mass of stone.

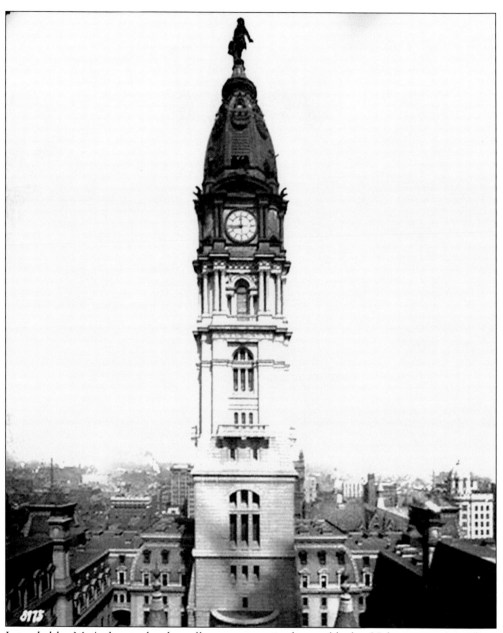

Intended by McArthur to be the tallest structure in the world, the 30 long years it took to construct the building allowed other late-19th-century construction projects to exceed city hall in height. Both the Eiffel Tower and the Washington Monument were taller; however, neither was a functioning building like city hall.

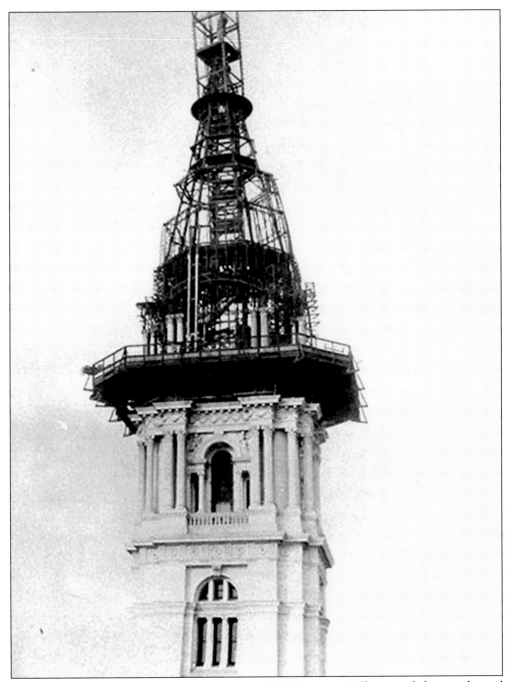

The generation-long campaign to construct Philadelphia City Hall required the coordinated effort of hundreds of skilled laborers, including carpenters, masons, carvers, stonecutters, and artists. The magnitude of the collaborative effort was nothing short of awesome, as the city hall project took longer to build than did the Great Pyramid in Egypt.

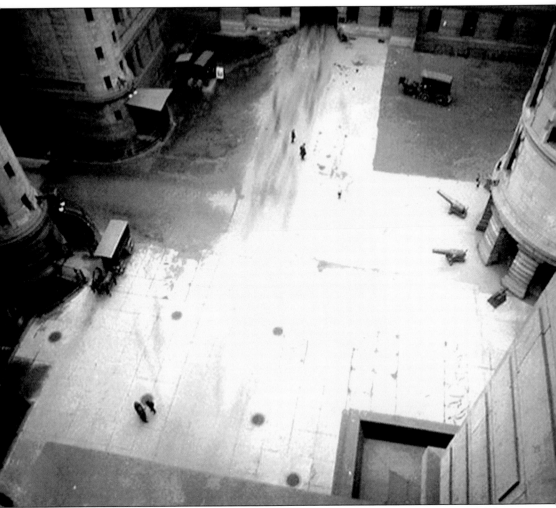

This stark, early morning photograph from early in the last century shows the Philadelphia City Hall courtyard bereft of its normal hustle and bustle as the crossroads of downtown Philadelphia. With the exception of old naval cannons, two carriages bringing prisoners to court, and a few pedestrians, the usually busy plot of ground is uncharacteristically quiet, almost desolate.

City hall tower placed an incredible amount of weight on the north foundation of the building. In fact, interior rooms under the tower had to be dispensed with, and additional blocks of granite were added to the walls and floors to shore up the foundation.

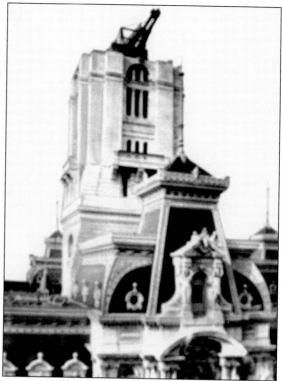

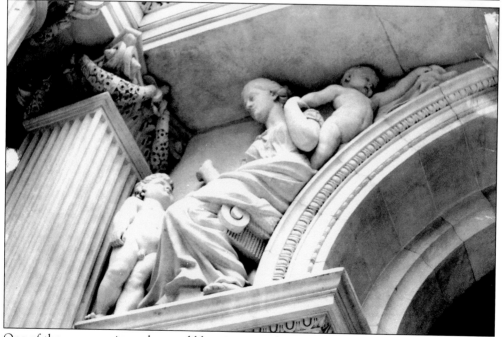

One of the more persistent but credible criticisms of McArthur and Calder's massive hulk was the height one had to scan with the naked eye to get a glimpse of the building's magnificent sculpture. Much of the sculpture is high up on the seven-story building, and beyond the view of the average passerby.

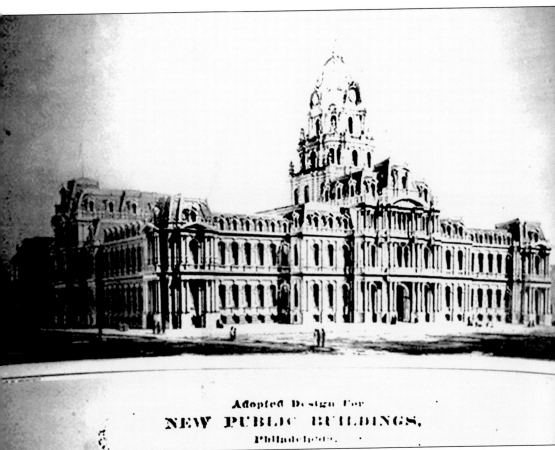

Adopted Design For
NEW PUBLIC BUILDINGS,
Philadelphia.

The state-authorized new Public Buildings Commission selected John McArthur Jr. as their architect for the massive project, and they were proud of his design, but controversy would remain a part of the campaign. Although the building's placement had been settled, citizens were still upset by it interrupting the normal flow of traffic at Broad and Market Streets. Moreover, the formal French design popular in post–Civil War America was no longer in favor by the time the building was completed in 1901.

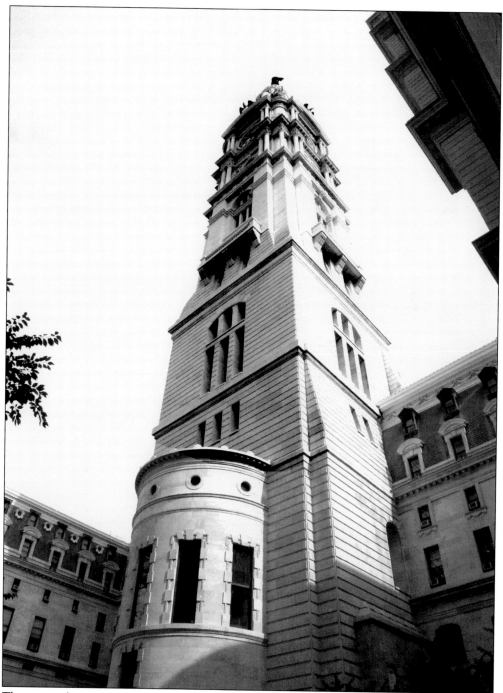

This ground view photograph of city hall tower demonstrates the awesome size of the structure. Designed to be the tallest building in the world, it was beat out by just a few years by two structures—the Eiffel Tower and the Washington Monument—neither of which was a functional building.

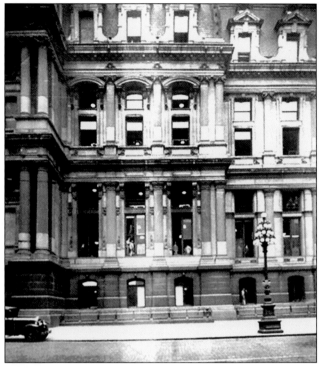

This 1930 photograph of city hall illustrates how McArthur's incorporation of French design affected his American architectural masterpiece. Large windows, prominent dormers, and grand columns lent the structure substance and allowed the building's six floors to be easily mistaken for three.

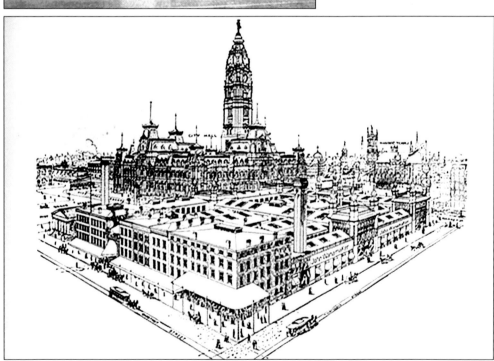

This sketch, dated *c.* 1900, graphically demonstrates how city hall dominated the Center City Philadelphia skyline. Drawn from the perspective of Thirteenth and Chestnut Streets, the sketch shows the early formation of John Wanamaker's department store and the westward flow of commercial businesses around a plot of ground that was once known as Penn Square.

McArthur's design for city hall borrowed greatly from French influences that were popular at the time. The Palais des Tuileries and the Louvre in Paris were particularly important in McArthur's vision of the building. Second Empire fashion can be seen in these early designs of a central portal, turreted corners, slate mansard roofs, dormer windows, and paired columns, all of which help make the building's six actual stories look like three. By the dawn of the 20th century, however, French architecture was somewhat passé in America, and people were already describing city hall in less-kind terms. According to one critic, it was a "magnificent pile."

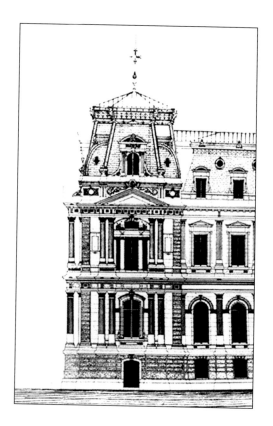

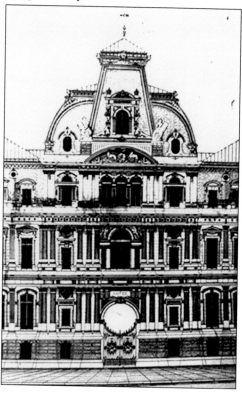

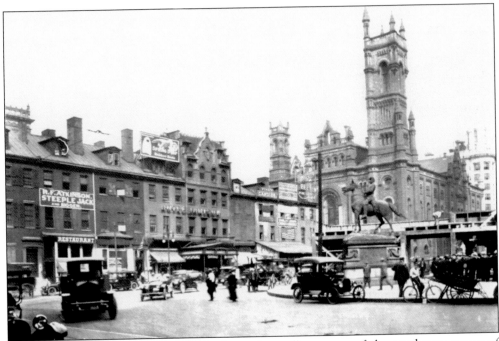

This photograph from the early 1900s shows the traffic pattern of the northwest corner of city hall. The statue of General McClellan can be seen in the foreground. On the right in the distance are the Masonic Temple and the building, with a flag on top, that was the home of the old *Evening Bulletin* newspaper.

This photograph, taken from the corner of Market and Juniper Streets, shows the right-hand turn motorists had to make when coming upon a dead end better known as city hall. For decades, disgruntled drivers moaned about city hall obliterating the intersection of Broad and Market Streets and destroying the normal flow of traffic. Some unaccustomed to the sudden one-way traffic pattern insisted on driving through the building's pedestrian portals.

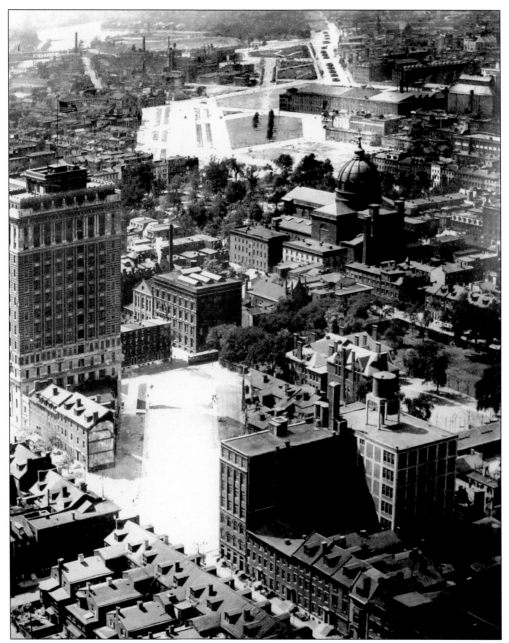

This c. 1920s photograph was taken from the city hall observation deck and shows the northwest quadrant of Center City Philadelphia prior to the construction of the Benjamin Franklin Parkway. The Cathedral-Basilica of Saints Peter and Paul can be seen on the right, and the Schuylkill River is on the far left. Notice that there is no Philadelphia Museum of Art at the end of what eventually became the Benjamin Franklin Parkway.

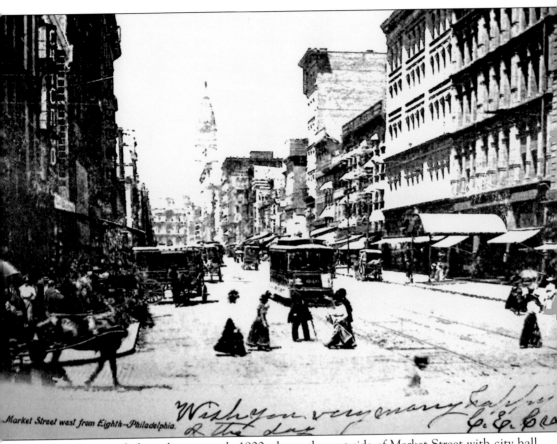

Market Street west from Eighth-Philadelphia.

This photograph from the very early 1900s shows the east side of Market Street with city hall off in the distance. Notice the horse-drawn carriages and some of the early electric trolleys. As can be quickly discerned, city hall easily dwarfed all other buildings in the city at the time.

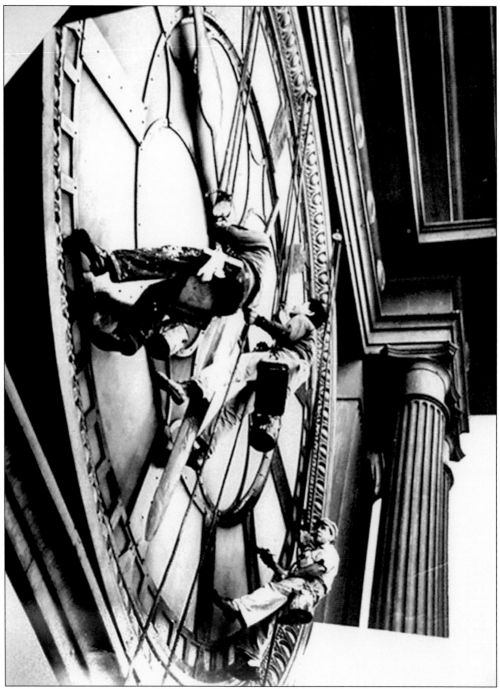

Steeplejacks give a facial to the city hall clock. One of the largest clocks in the world, it was completed in 1898. The 50-ton timepiece is 360 feet above the sidewalk and was originally operated by compressed air. Each minute hand is 16 feet 8 inches in length and weighs 225 pounds, while the hour hands are 11 feet 10 inches in length and weigh in at 185 pounds.

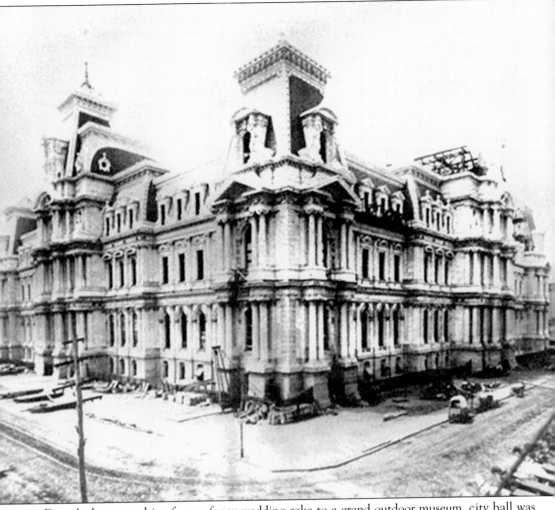

Described as everything from a fancy wedding cake to a grand outdoor museum, city hall was a testament to late-19th-century America's fascination with French architecture. Mansard roofs and pavilions, spandrel reliefs, central dormers, and extravagant ornamentation were all consistent with the strong French influence of the day.

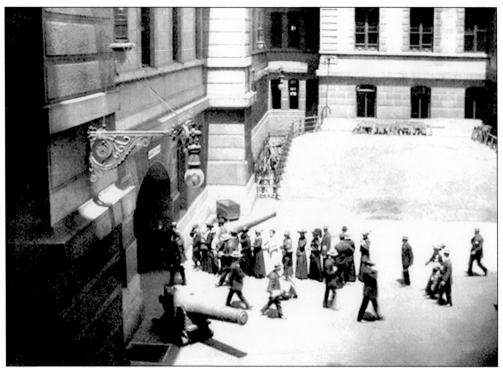

At one time, massive naval cannons graced the courtyard of city hall. Workmen hauled one of the 9,300-pound cannons through the courtyard to make way for improvements to the Broad Street subway. The cannons, taken from Admiral Farragut's old wooden frigate the S.S. *Richmond,* which saw action during the Civil War, were placed in the city hall courtyard in 1899. Pushed from pillar to post during the 1930s, the last cannon was finally returned to the navy yard in 1936.

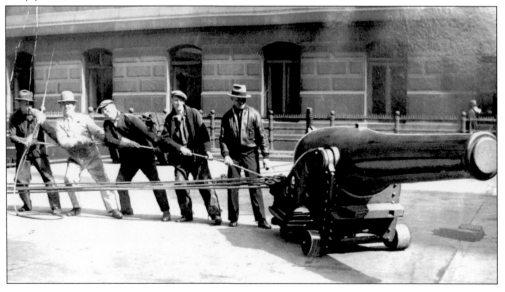

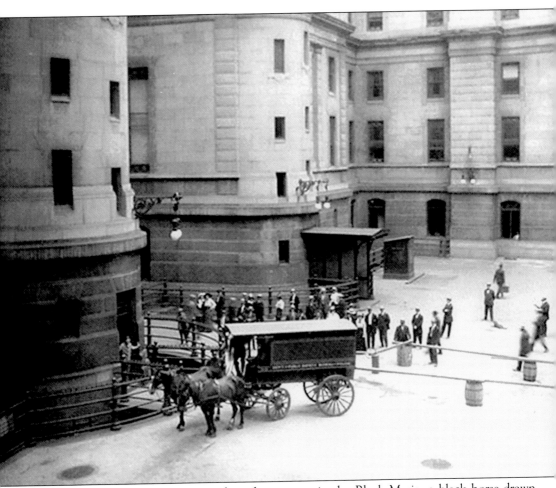

In the early years, prisoners were brought to court in the Black Maria, a black horse-drawn carriage that entered city hall courtyard from the west and went directly to the prisoners' own private entrance. This 1914 photograph shows curious pedestrians taking in the arrival of another complement of thieves, bank robbers, and murderers.

Intended by McArthur to be the tallest structure in the world, the 30 long years it took to construct the building allowed other late-19th-century construction projects to exceed city hall in height. Both the Eiffel Tower and the Washington Monument were taller; however, neither was a functioning building like city hall.

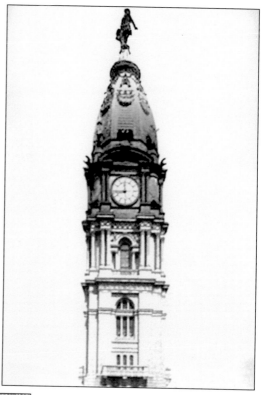

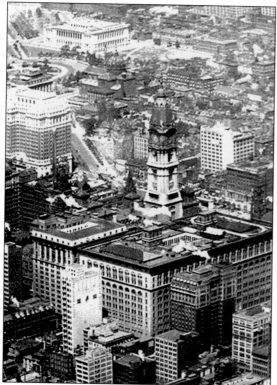

This photograph of city hall with John Wanamaker's department store in the foreground shows Logan Circle and the relatively recent construction of the Benjamin Franklin Parkway that now ends at the Philadelphia Museum of Art. Also visible is the dome of the Cathedral-Basilica of Saints Peter and Paul and the new Free Library of Philadelphia on Vine Street.

As the hub of city government, city hall was the embodiment of public will. Official occasions were appropriately celebrated and recognized. This 1930 photograph shows the flags on top of the building at half-staff upon the notification of the death of former president William Howard Taft.

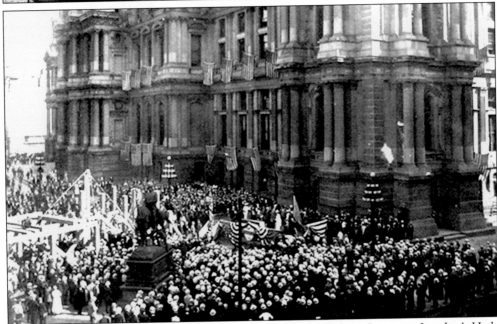

For many a decade, the north plaza of city hall resembled Speakers Corner in London's Hyde Park as impassioned orators pontificated on the troubles of the world. As one local scribe wrote of the scene, "So it goes day after day. Religious speakers sandwiched between soapbox orators, amateur politicians and Reds, all kings for an hour." In this 1915 photograph, the amateurs have been moved out to make room for the professional politicians.

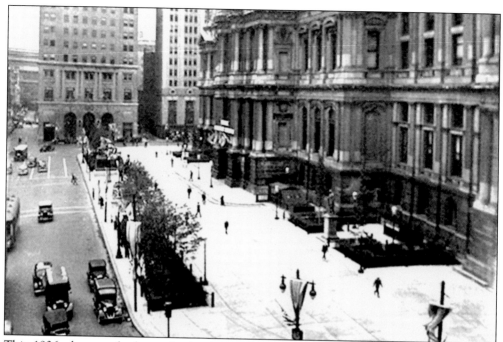

This 1936 photograph shows the landscaping and statuary on city hall's north plaza as it existed during the Depression. Though it was periodically altered according to artistic and practical dictates of the times, it nearly resembles its present configuration. The building in the background is Philadelphia City Hall Annex.

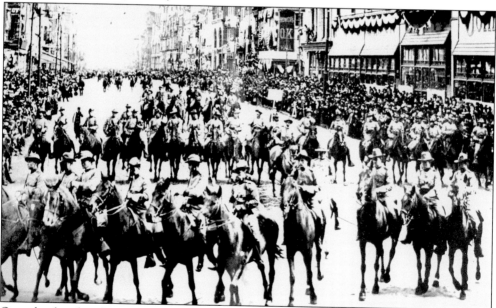

Over the decades, the citizens of Philadelphia witnessed a number of celebratory parades. One of the most moving was the Peace Jubilee parade of 1898, when President McKinley reviewed 25,000 soldiers and sailors marching around city hall in the aftermath of the Spanish-American War. This photograph shows the famed Rough Riders on horseback leading the procession as they approach city hall.

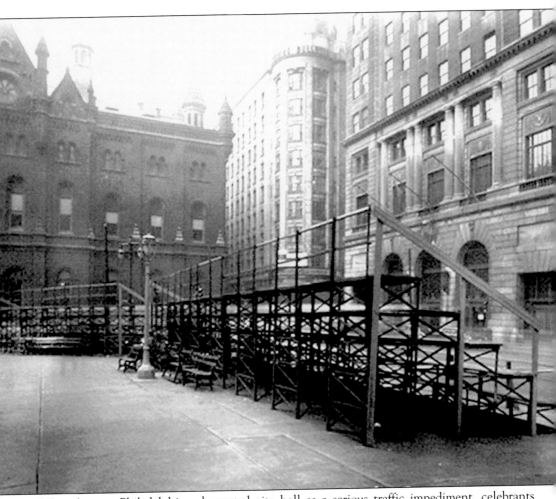

Though most Philadelphians lamented city hall as a serious traffic impediment, celebrants found the square five-acre site a natural parade route. Christmas and New Year celebrations along with ethnic and patriotic celebrations made tours around city hall, where stands were erected for visiting dignitaries and local celebrants. This early morning photograph from 1949 shows the viewing stands, located on the north and northeast corners of city hall, awaiting the throngs of spectators.

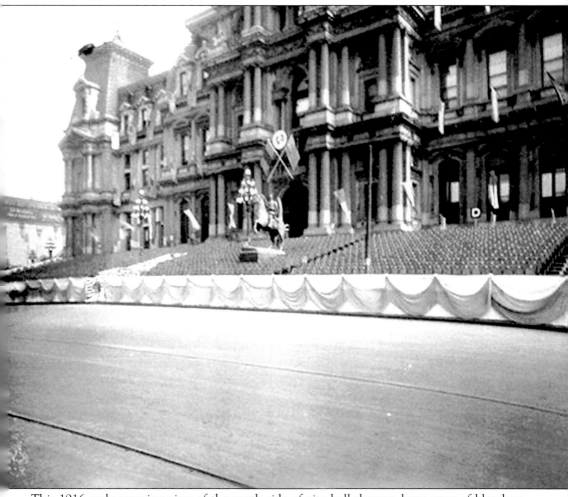

This 1916 early morning view of the north side of city hall shows a large array of bleachers awaiting a throng of parade spectators. Only a statue of a Civil War general astride his trusty steed disturbs what will soon be several thousand exuberant viewers of a parade.

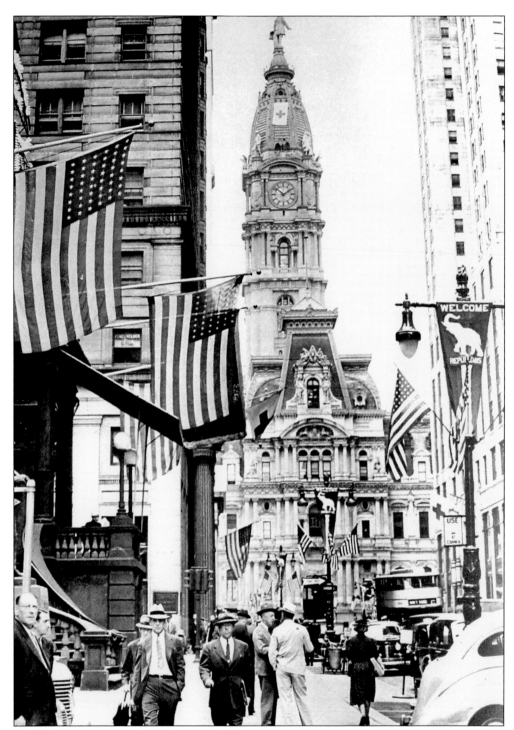

As the nation's third largest city through most of the 20th century, Philadelphia hosted a number of political conventions. This photograph with city hall in the background and the Union League on the left shows Broad Street decked out with flags and political banners for the 1940 Republican National Convention.

Travelers and tourists to Philadelphia were immediately impressed with the building. Both domestic and foreign travelers sent postcards of city hall back home to their loved ones illuminating one of the most impressive structures they had seen in the city, or anywhere else for that matter.

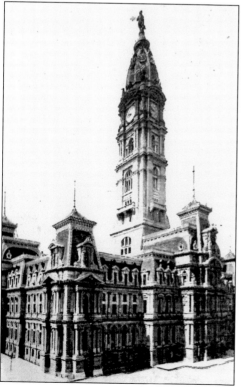

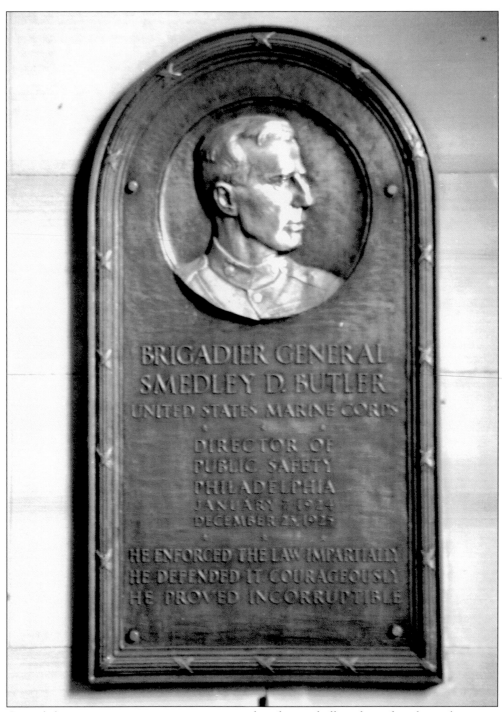

BRIGADIER GENERAL
SMEDLEY D. BUTLER
UNITED STATES MARINE CORPS

DIRECTOR OF
PUBLIC SAFETY
PHILADELPHIA
JANUARY 7 1924
DECEMBER 23 1925

HE ENFORCED THE LAW IMPARTIALLY
HE DEFENDED IT COURAGEOUSLY
HE PROVED INCORRUPTIBLE

One of the more interesting stories associated with city hall is that of a plaque honoring Gen. Smedley Butler. A Marine Corps general of considerable accomplishment, Butler was brought to Philadelphia in the 1920s to route out corruption and take command of the police department. After several years of considerable but futile effort, General Butler threw up his hands, declared the job impossible, and left the city.

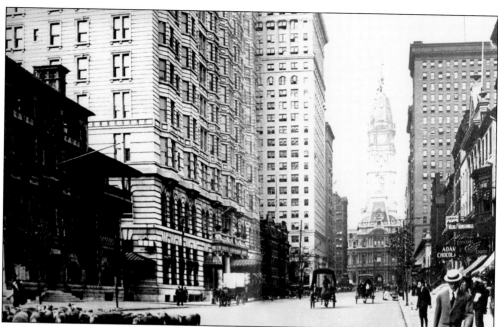

By the early years of the 20th century, Philadelphia had its share of imposing structures, including large commercial buildings and lavish hotels. The Bellevue-Stratford Hotel, on the left in the above photograph, was one of the city's more prestigious landmarks. Despite the new construction and dominance of city hall in the background, it was not unusual to see herds of sheep marching along South Broad Street, as the 1905 photograph shows. The 1920 photograph on the right shows the east side of South Broad Street with the Ritz-Carlton Hotel in the foreground.

This 1900 photograph with city hall in the background shows the first block of North Broad Street from Arch Street. Though motorized vehicles were available, horse-drawn carriages were clearly the dominant form of travel. Shown on the left is the Masonic Temple.

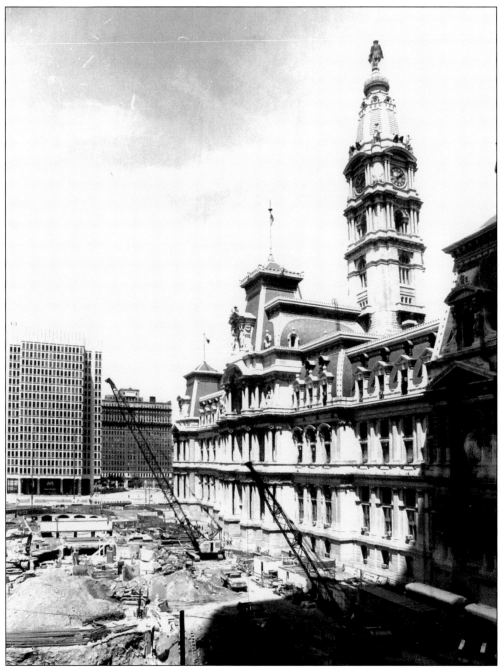

The west side of city hall has witnessed several reconfigurations over the past century. This photograph shows construction work underway once again in an effort to make Dilworth Plaza an appealing venue for tourists and local residents alike.

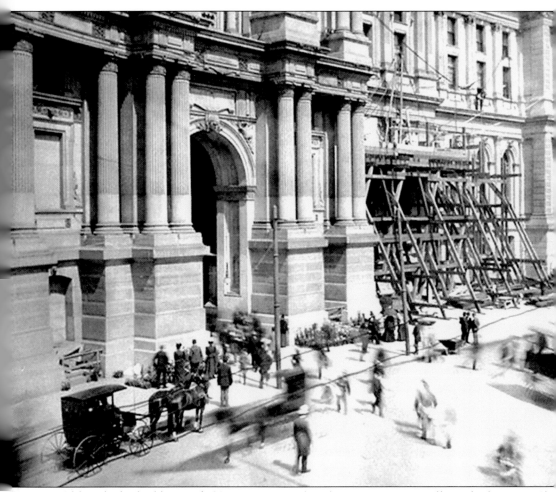

Although the building took 30 years to complete (some argue it actually took closer to 40), city hall was a functioning municipal office building from the very beginning. This photograph demonstrates the busy nature of the building while construction and sculptural additions were still taking place.

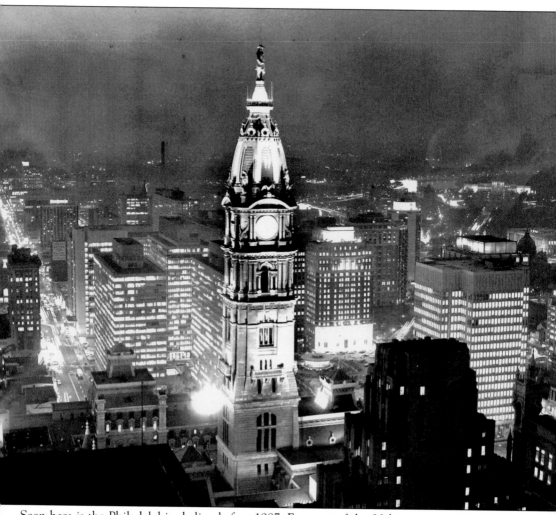

Seen here is the Philadelphia skyline before 1987. For most of the 20th century, an unwritten rule was observed that no building should exceed Penn's hat in height. Today, Liberty Place and a number of other skyscrapers on the west side of city hall practically dwarf the 547-foot statue of Penn.

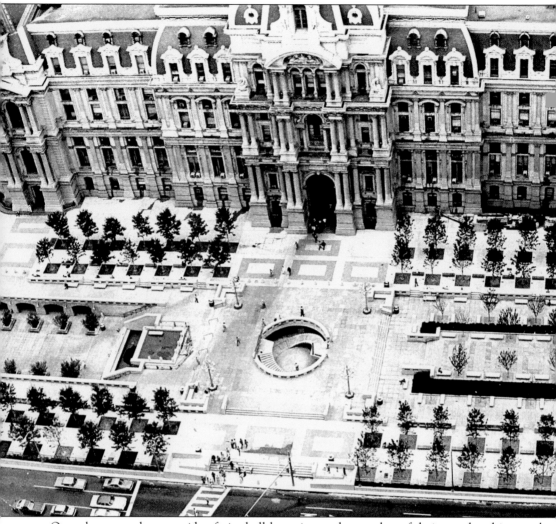

Over the years, the west side of city hall has witnessed a number of design and architectural permutations. In hopes of facilitating an attractive ambiance for pedestrians entering the building and for public events, various conceptual plans have been implemented. This aerial photograph of Dilworth Plaza shows one of the more recent architectural designs.

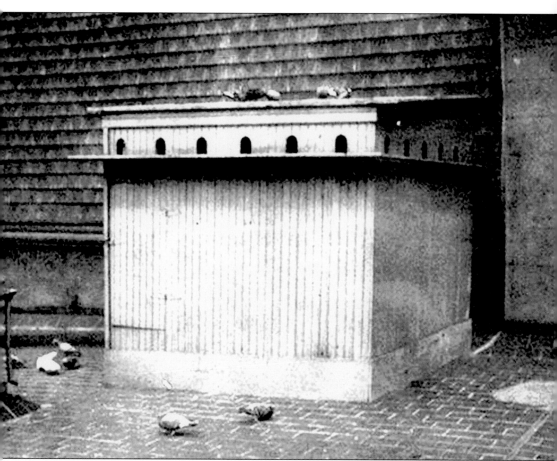

Although starlings and pigeons presented a persistent health problem and caused 60 tons of bird droppings to be removed from the building each year, custodians did their best to provide adequate housing for city hall's feathered friends. This photograph shows a hotel that was constructed on the roof of the building for those winged visitors.

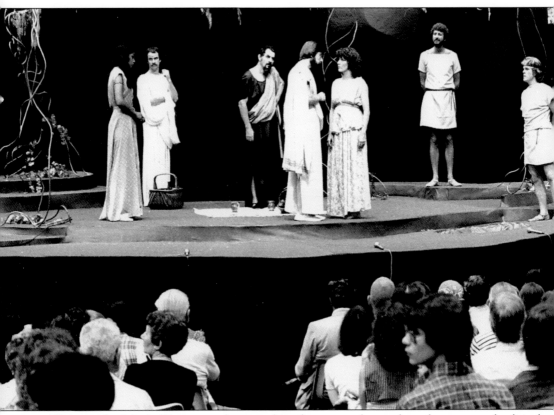

The grounds of city hall have served as everything from an outdoor sculptural museum and political rally ground to a meeting place and parade route. This 1978 photograph shows the presentation of William Shakespeare's *A Midsummer Night's Dream* in the theater in the courtyard.

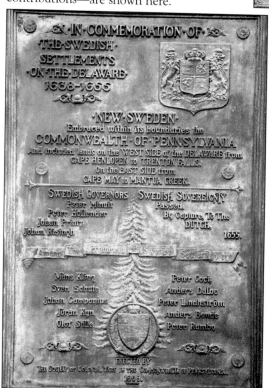

Various groups and individuals are honored with plaques in city hall for their contribution to the settlement of Philadelphia. On display on the ground floor of the building are 14 such plaques. Two plaques—for Dutch and Swedish contributions—are shown here.

Dutch plaque:

IN·COMMEMORATION·OF
THE·DUTCH·
SETTLEMENTS
·ON·THE·DELAWARE·
1623–1664
THE TERRITORY OCCUPIED BY THE
DUTCH
WEST·INDIA·COMPANY·
And Known As
NEW·NETHERLAND·
Extended from the Capes of the Delaware to the Connecticut River
And Embraced within its boundaries the
COMMONWEALTH·OF·PENNSYLVANIA

DIRECTORS GENERAL
OF THE DUTCH
WEST INDIA COMPANY

Adriaen Jorissen Tienpont
Cornelis Jacobsen Mey
Willem Verhulst
Peter Minuit
Wouter Van Twiller
Willem Kieft
Peter Stuyvesant

CHRONOLOGY
NEW NETHERLAND

Captured by the ENGLISH 1664.
Recaptured by the DUTCH 1673.
Ceded to the ENGLISH 1674.
CHARTER granted by
KING CHARLES II to WILLIAM PENN
for the territory since known as
PENNSYLVANIA
March 4, 1681

ERECTED BY
The Society of Colonial Wars in the Commonwealth of Pennsylvania
1908.

Swedish plaque:

·IN·COMMEMORATION·OF·
·THE·SWEDISH·
·SETTLEMENTS·
·ON·THE·DELAWARE·
1638–1655

·NEW·SWEDEN·
Embraced within its boundaries the
COMMONWEALTH·OF·PENNSYLVANIA
And included lands on the WEST SIDE of the DELAWARE from
CAPE HENLOPEN to TRENTON FALLS.
On the EAST SIDE from
CAPE MAY to MANTUA CREEK.

SWEDISH GOVERNORS
Peter Minuit
Peter Hollender
Johan Printz
Johan Rising

SWEDISH SOVEREIGNTY
Passed
By Capture, To The
DUTCH.
1655.

Among The Prominent Swedish Settlers Were

Mans Kling
Sven Schute
Johan Campanius
Jöran Kyn
Olof Stille

Peter Cock
Anders Dalbo
Peter Lindström
Anders Bonde
Peter Rambo

ERECTED BY
The Society of Colonial Wars in the Commonwealth of Pennsylvania.
1908.

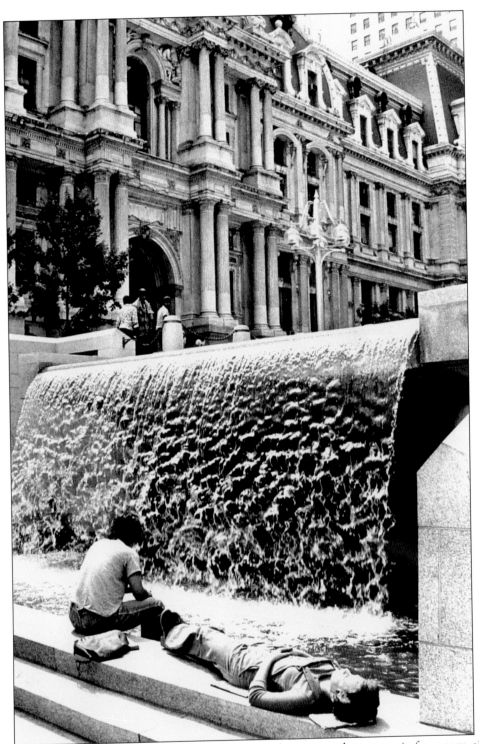

Dilworth Plaza, on the west side of city hall, has become a pleasant oasis for weary city employees and busy shoppers. Two waterfalls provide a wet, if not bucolic setting in the city for lunchtime visitors looking for a quiet place to rest.

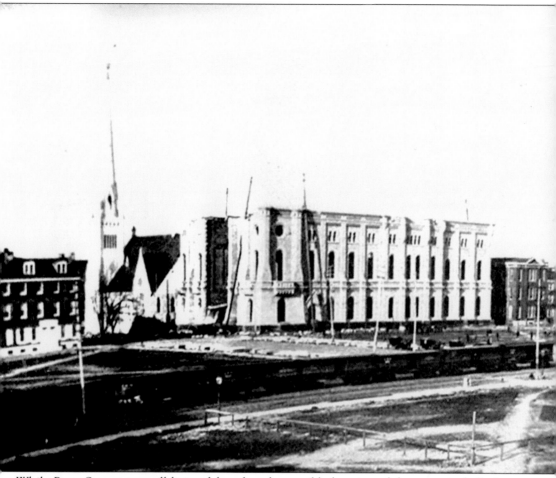

While Penn Square was still being debated as the possible location of the new city hall, the Masonic Temple was climbing upward and nearly complete. The center of Philadelphia was moving westward, and the Masonic Temple would soon have a new neighbor, albeit one that took over a quarter-century to finally move in.

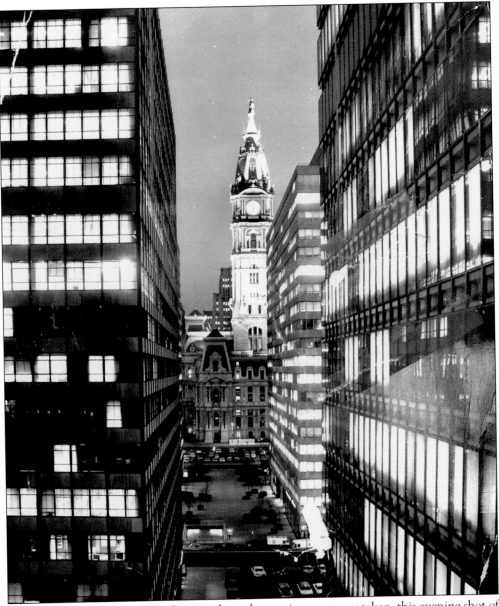

Taken over 100 years after the photograph on the previous page was taken, this evening shot of city hall from Seventeenth Street shows the stark contrast between late-19th and 20th-century Center City Philadelphia. Penn Center Plaza, once the gem of Center City, is now nearly 50 years old itself.

Two

THE STATUE OF WILLIAM PENN

Originally, the statue of a figure of Justice sat atop John McArthur's wood model of city hall. By 1872, however, Penn had supplanted the statue of Justice, but no one seems to be quite sure why the substitution had taken place. Regardless, the assignment of creating the statue engendered much interest in the artistic community, more so than all the rest of city hall's 250 pieces of sculpture. Although a number of prominent sculptors applied for the position, and some even submitted models and designs, Alexander Milne Calder had already favorably impressed the Public Buildings Commission as the project's plaster modeler and won the assignment.

Born in Scotland, Calder had come to America in 1868 after learning his craft from some of the best sculptors in Edinburgh, London, and Paris. Many European sculptors found America an attractive destination since homegrown sculptors considered ornamental sculpture unworthy of their talents. Calder seized the opportunity and thereby became the creator of the largest sculptural program of any building in the United States.

Although the Penn statue atop the Philadelphia City Hall tower was shown in drawings as early as 1872, it was more than 20 years before the famous statue of Penn actually assumed that lofty position. For many of those years, Calder was busy developing the other 250 pieces of sculpture for the building. In 1886, however, Calder suspended all other work on the building to concentrate on the Penn statue. The sculptor first made a nine-foot clay model and then enlarged it until it reached its final staggering height of 37 feet. Calder and his assistants then made a plaster cast of the awesome figure in 1888, but the statue sat untouched for nearly two years. The problem was that there was no foundry in the United States capable of casting the nearly four-story, 27-ton statue. Finally, with the opening of Tacony Iron and Metal Works in northeast Philadelphia in 1889, work could begin on the statue. Three years later, the bronze statue of Penn was back in the Philadelphia City Hall courtyard for all to see and admire. The statue remained there for more than one year, until it was finally raised in 14 separate pieces to its lofty perch high above the city on November 28, 1894.

Regrettably, Calder was never happy with the statue. His dismay had nothing to do with the statue itself, but the fact that Penn was facing northeast, a direction that left his face in the shadows for most of each day. Calder blamed the poor positioning on William Bleddyn Powell, the supervising architect who replaced McArthur upon his death in 1890. Although Calder was correct that a southern exposure would have cast more sunlight on Penn's face, it seems clear that from the earliest days of the project the statue was to face Penn Treaty Park, the site where Penn secured his peace treaty with the local Leni Lenape Indians.

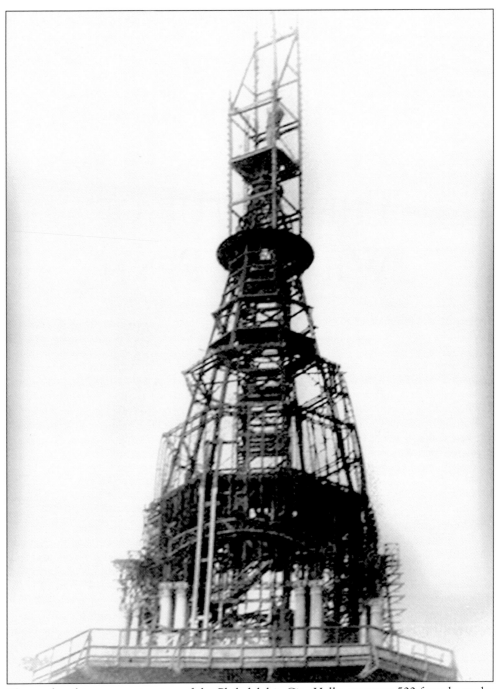

The steel and iron superstructure of the Philadelphia City Hall tower rose 500 feet above the street prior to the placement of the statue of William Penn on top in 1894.

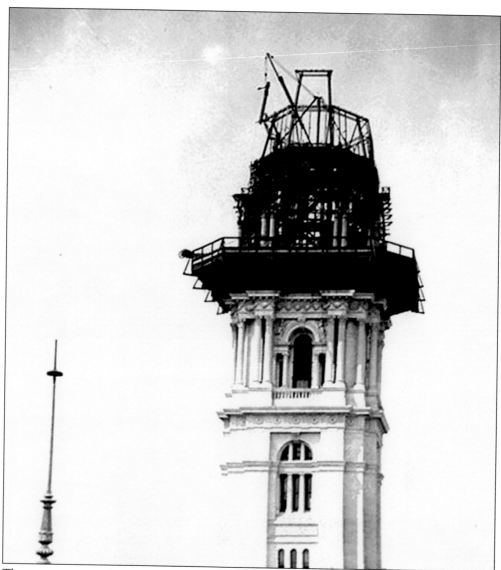

The construction of city hall tower was a long, dangerous process. Ironworkers had to deal with unprecedented heights, primitive equipment, and a complicated structure requiring 4,000 pieces of iron, bronze, and copper.

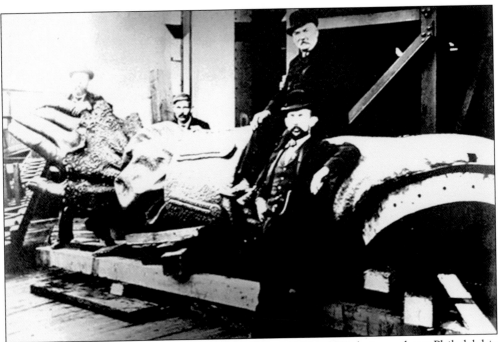

Calder's statue of Penn was molded by the Tacony Iron and Metal Works in northeast Philadelphia and then transported down Broad Street to city hall. The statue's 14 pieces were assembled in city hall's courtyard in 1894 and remained there for a year to allow the curious to admire the statue before it was once again disassembled and lifted to the top of the tower. These photographs show the statue's legs and right arm before assembly. The arm is 12.5 feet in length.

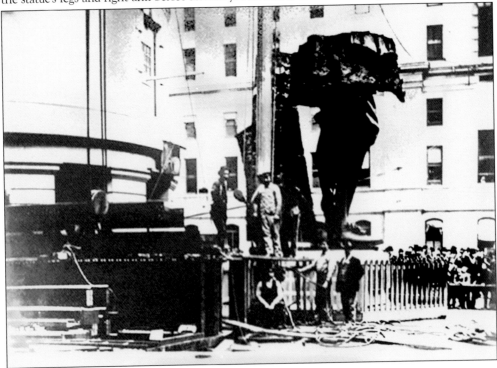

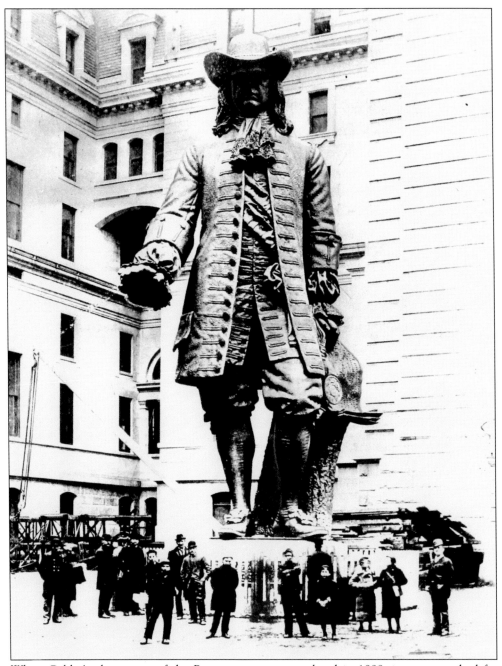

When Calder's plaster cast of the Penn statue was completed in 1888, it sat untouched for almost two years due to the absence of a foundry in the United States capable of casting the enormous figure. In 1889, the Tacony Iron and Metal Works of Philadelphia was awarded the contract to build the largest and heaviest bronze statue in the world.

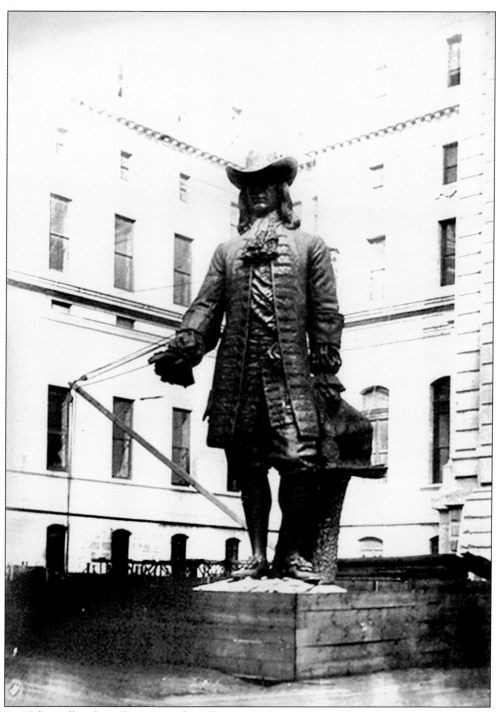

At 37 feet tall and weighing more than 27 tons, the bronze statue of Penn was Alexander Milne Calder's most famous work. Prior to being raised to the top of city hall tower on November 28, 1894, the statue was displayed in the courtyard. For more than a year, many came to marvel at the giant metal statue of Pennsylvania's founder.

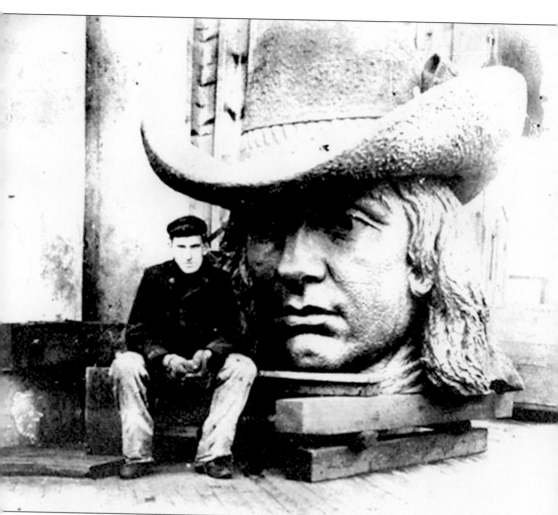

While the statue of Penn was periodically assembled and disassembled for transport and placement on the tower, citizens had an opportunity to grasp the awesome dimensions of the statue. The circumference of Penn's hat was 23 feet, his nose and eyes were 18 and 12 inches in length, respectively, and a strand of his hair was 4 feet long.

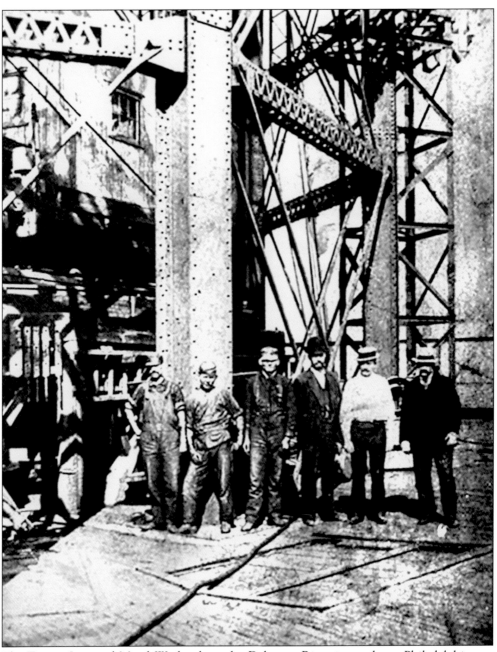

The Tacony Iron and Metal Works along the Delaware River in northeast Philadelphia was the only metal foundry large enough to handle the difficult task of building the largest human statue in the world. Calder's plaster cast of Penn had to wait more than a year before a foundry sophisticated enough to take on the awesome task was up and running.

Although Calder was upset by the placement of his grand statue of Penn facing northeast, there is reason to believe it was always designed to face in that direction. Calder blamed W. Bleddyn Powell, the supervising architect, for the directional miscue, but documents going back to the early 1870s show the statue looking in that direction. In addition, the sculptures of the Native American and Swedish families just under Penn are arranged north and south as the colony's founder discovered them when he arrived in the 1600s.

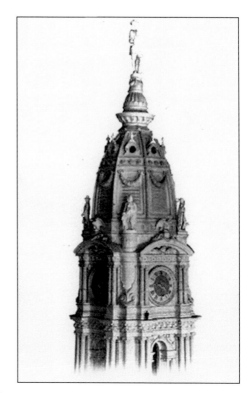

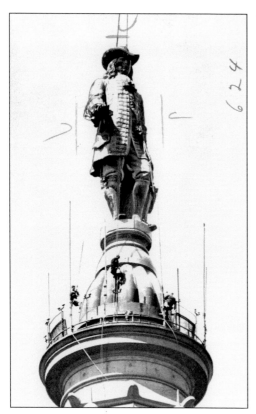

While the statue of Penn was considered Alexander Milne Calder's greatest work, he remained disappointed to his dying day about its placement on the tower. Calder was unhappy that the architect called in to replace McArthur (upon his death in 1890) had the statue face the northeast, thereby dooming the statue to shadows or perpetual silhouette. To the sculptor's great dismay, Penn's face was cast in darkness for most of each day.

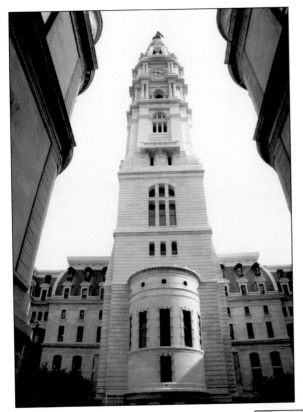

This ground view photograph of city hall tower demonstrates the awesome size of the structure. Designed to be the tallest building in the world, it was beat out by just a few years by two structures—the Eiffel Tower and the Washington Monument—neither of which was a functional building.

While thousands of local residents and foreign tourists tour city hall each year, the statue of Penn is by far the most visited site in the building. Nearly 30,000 tourists each year take the elevator 500 feet up to the observation deck to get an up close and personal view of Calder's master work and get a bird's-eye view of Philadelphia.

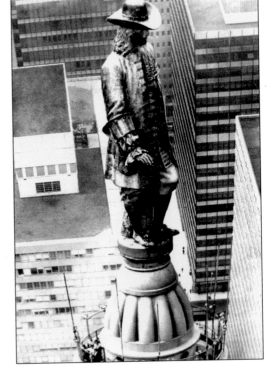

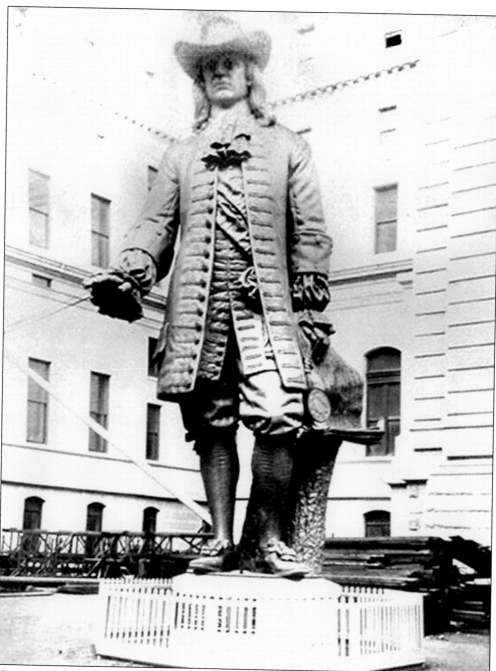

As most Philadelphians took great pride in the statue of Penn, there were some who argued that the sculptor had gotten it wrong. One historian argued that Penn was given a cowboy hat rather than one with a low crown and a wide brim that members of the Society of Friends actually wore. The historian also argued that, according to Quaker tradition, his coat should have been much plainer and should have reached down to his ankles. The fancy flourishes and ornate trim, according to this one detractor, were more appropriate for an English dandy, not Pennsylvania's stoic founder.

For over a century, awed travelers, both local and foreign, have taken the elevator to the top of the city hall tower to get a bird's-eye view of Philadelphia. From the Schuylkill to the Delaware and from the River Wards in the north and to the southern most reaches of South Philadelphia, the observation deck of city hall presented the best perch to see the city.

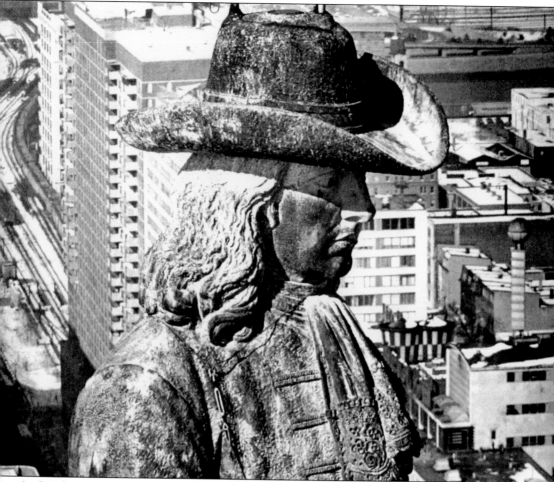

At 548 feet in height, Penn's hat was the tallest point in the city for nearly a century. A trap door in the top of the hat allowed steeplejacks to periodically provide maintenance to the statue. The statue's positioning towards the northeast fosters a shadow across Penn's face for most of each day.

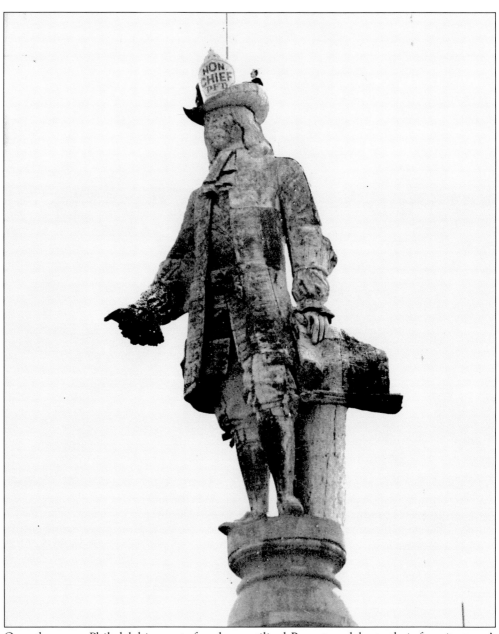

Over the years, Philadelphia sports fans have utilized Penn to celebrate their favorite team's fortunes come playoff time. Periodically, the statue has been draped in Flyers, Phillies, and Eagles sports garb. This photograph shows Penn wearing a Philadelphia Fire Department helmet as the honorary chief of the local firefighters.

Three

CITY HALL SCULPTURE

Although the statue of Penn atop Philadelphia City Hall is by far the most famous piece of sculpture associated with the building, it is by no stretch of the imagination the only one. Incredibly, there are over 250 relief and freestanding sculptures on the building, all created by Alexander Milne Calder and his able assistants.

The sculptural program designed by McArthur, Perkins, and Calder is one of the most impressive, diverse, and extensive on any building in the world. The depictions represent a wide range of topics, including history, allegory, mythology, humans, animals, and plant life from throughout the world. Included are figures that symbolize liberty, scientific accomplishment, virtue, and vices. Most of the figures were strategically designed for specific sections of the building in concert with what went on there. For example, the south side of the building contained the judiciary and the courts, so the south façade displayed the face of Moses over the south portal and colossal freestanding figures of Law and Justice. On the west side of the building, where prisoners entered the courtyard, were the deep-lined features of Sympathy with a crown of chains around the forehead in the portal keystone, while spandrels illuminated the figures of Prayer and Meditation.

Not all of the sculpture was as bleak. Some pieces, in fact, could be downright humorous, as was the portal alcove that displayed a series of whimsical cats, a few showing grinning felines chomping on captured mice. Although one newspaper argued such scenes represented the building commission preying on "helpless tax-paying people," it is more likely that the figures were McArthur's gift to the building commission's chairman, who was a known cat lover.

Calder's iconography was remarkable for its variety of symbolism. In the crypt under the clock tower, for example, were four huge marble columns crowned by capitals portraying straining half-figures of four different races of man representing the continents of Europe, Asia, Africa, and North America. This theme was impressively repeated on the exterior by the colossal male and female caryatids, which support the dormers of the central pavilions of each façade. Arguably, some of the most impressive pieces of sculpture were the 24-foot figures of Swedish and Native American families directly under the Penn statue on the tower. Representing native inhabitants and the first European settlers, the figures are remarkable for their craftsmanship and beauty.

Calder may have considered his statue of Penn his crowning achievement, but his other building decorations are nothing short of first-rate and solidify his reputation as one of America's most gifted architectural sculptors.

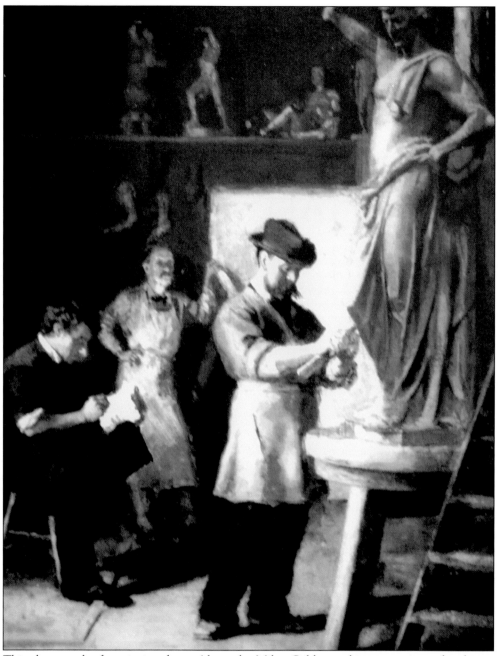

This photograph of a painting shows Alexander Milne Calder working on a piece of sculpture in his first-floor salon. Calder was one of the first to occupy space in city hall in order to complete his vast sculptural program that included over 250 artistic items.

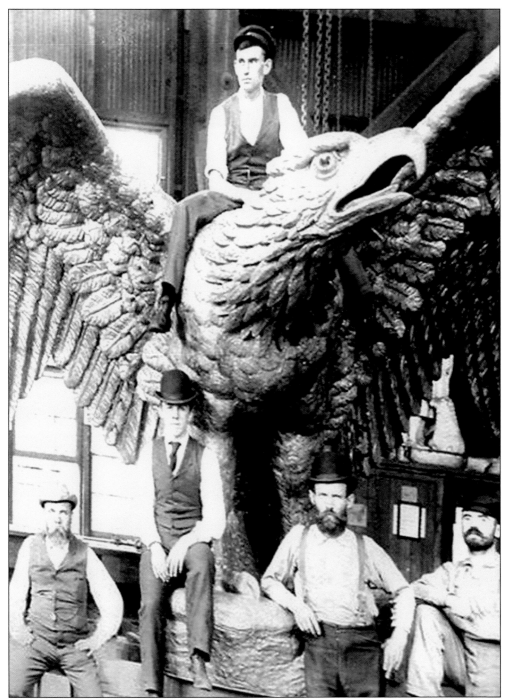

Alexander Calder was officially classified a maker of plaster models for the project. His 250 clay models for the building are the equivalent of a lifetime's work for some artists. Although he had a number of studio assistants that helped him transfer clay models into plaster, which then became life-size stone and bronze figures, the sculptural program was by any measure a monumental artistic campaign.

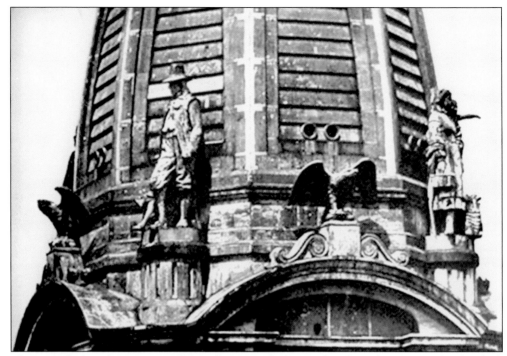

The great clock in the tower is 26 feet in diameter. The minute hand weighs 225 pounds. The clock was originally lit by candles and later by 552 light bulbs. The statues above the clock represent early Swedish settlers who came to the area before Penn. The statues may appear small from ground level, but they are, in fact, 24 feet tall. The eagle next to them has a 12-foot wingspan.

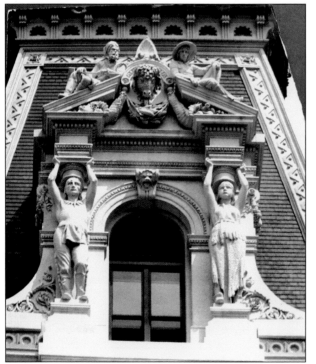

The attic pediments on the upper stories of the four pavilions represent four of the world's continents. The western pavilion shown here is representative of North America with Native American caryatids and a bison's head peeking out of the tympanum. Here, one can see the seal of the city symbolized by representations of both land and sea on the shield in the center.

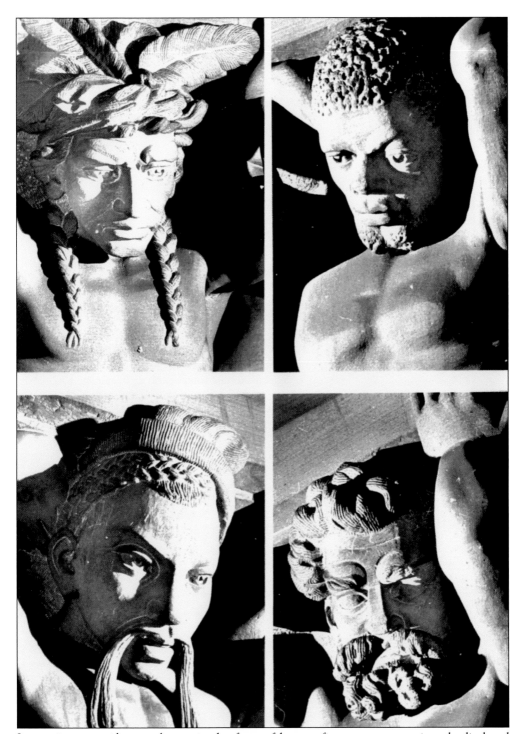

Impressive caryatids, or columns in the form of human figures, were prominently displayed around the building. Calder wanted his sculpture to become part of the structural fabric of the building. Marble columns portrayed straining half-figures of four different races of man representing the four continents of Europe, Asia, Africa, and North America.

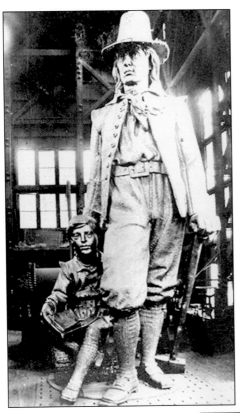

Although Calder is most famous for his statue of Penn, his other large statues are equally impressive. Regrettably, some of these are placed so high that they are somewhat difficult for the observer on the ground to fully appreciate. Here, before their placement on the tower, are the Swedish settler and the Indian brave. While there has been much speculation as to McArthur's contribution to the statuary program, there is evidence to suggest that, at the very least, he had considerable input into the statues' placement on the building.

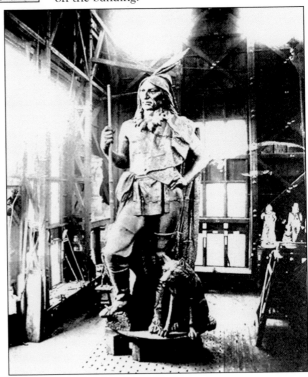

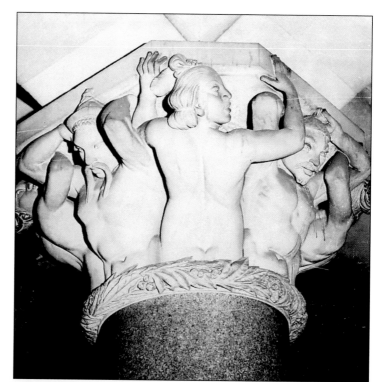

Inside the north portal under the tower can be seen the capitals of four huge marble columns. These columns portray the straining half-figures of four different races of man representing the four continents of Asia, Africa, Europe, and North America.

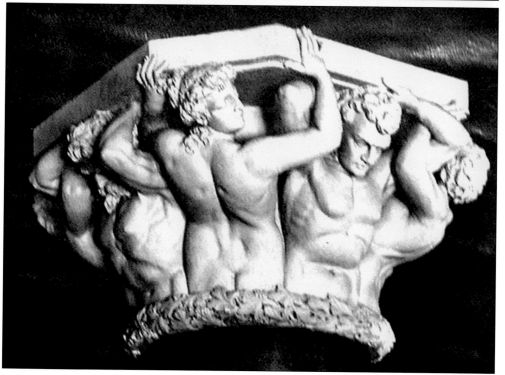

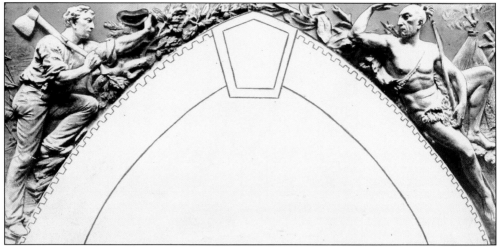

Calder's designs for the building were clearly emblematic. Most human figures, nude or clothed, had definite symbolic importance. The north portal was most closely reflective of the city's history. Above the portal was a portrait of Penn flanked by spandrel figures depicting the evolution of the state: an apprehensive Native American and a pioneer settler with an axe, which some believe represent barbarism and civilization.

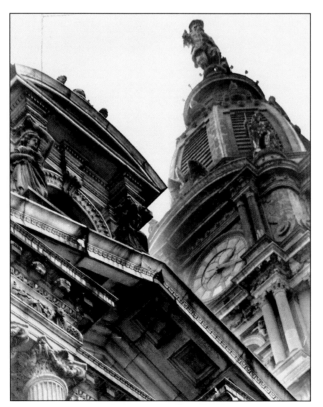

McArthur's prize-winning design for the building in 1869 was French inspired; however, the building's lines were uncluttered and sculpture was largely ignored. In time, modifications to the original design were instituted, and by its completion in 1901, city hall was cloaked in sculpture to the point that it had arguably become the most important program of architectural sculpture in 19th-century America.

Entering the south portal of city hall the image of Justice, a blindfolded woman, is seen in the keystone portion of the arch. The imagery symbolized the judiciary, and the hope of some that the building would be viewed as the temple of justice. The large southern half of the building, from the first through sixth floors, was devoted to the courts and the county and state judicial system.

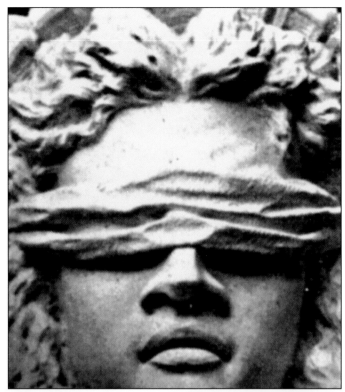

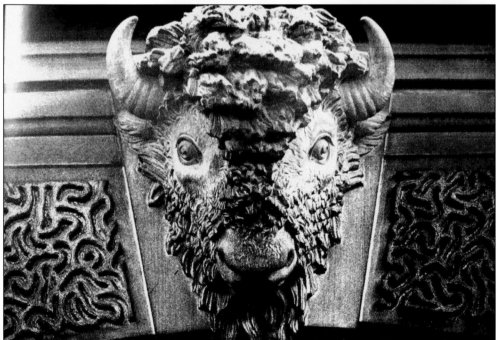

Alexander Milne Calder intermingled naturalistic and neo-baroque elements of the Beaux-Arts tradition in his sculpture. Both native foliage and animals were accurately, yet decoratively, depicted over much of the building.

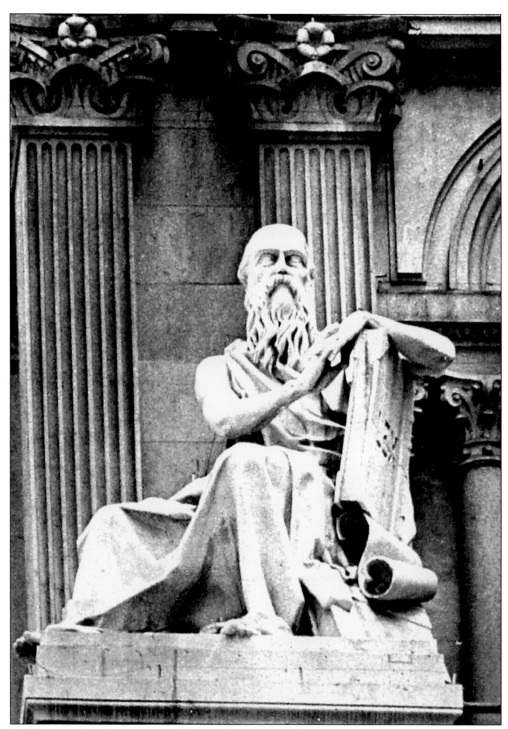

Calder wanted each entrance of the building to be adorned with sculpture that represented the type of business or governmental function that occurred there. The south entrance was designed for the courts, and was therefore cloaked with items symbolizing law, its benefits and history, the head of Moses, and the seated figures of Law and Liberty.

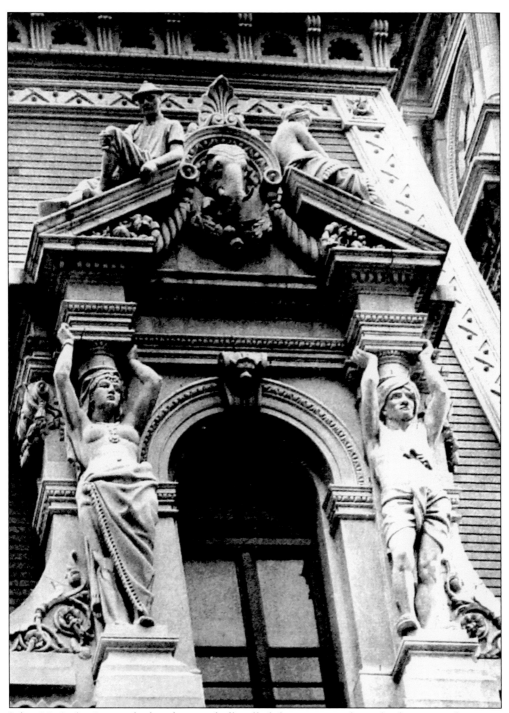

John McArthur's initial plan for city hall called for sparse sculptural adornment; however, as the years passed, a more extensive plan emerged so that by its completion in 1901, city hall represented the most comprehensive sculptural program in 19th-century American architecture. The package was a collegial effort combining the talents of McArthur, building commissioner Samuel Perkins, and Alexander Calder.

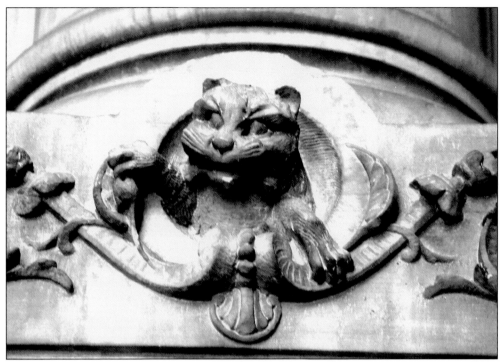

Mischievous cats are liberally displayed throughout the interior of the south portal. No one is quite sure of the origin or symbolic importance of these humorous felines along the walls, but most architectural scholars of city hall believe it was McArthur's way of paying light-hearted homage to Samuel Perkins, the chairman of the important Public Buildings Commission. One silhouette actually shows a grinning, triumphant cat with a mouse in its mouth.

CORNER STONE
OF THE
PUBLIC BUILDINGS OF THE CITY OF PHILADELPHIA
LAID JULY 4, 1874

In the presence of the Mayor of the City, the Select and Common Councils, Heads of Departments, and other distinguished Civil, Military and Naval Officials, and a large concourse of citizens.

By ALFRED R. POTTER, Esq.,
R.W. GRAND MASTER OF MASONS OF PENNSYLVANIA AND MASONIC JURISDICTION THEREUNTO BELONGING, ASSISTED BY HIS GRAND OFFICERS AND ACCORDING TO THE ANCIENT CEREMONIES OF THE CRAFT.

Orator — **BENJAMIN HARRIS BREWSTER.**

President of the United States—ULYSSES S. GRANT. Governor of Pennsylvania–JOHN F. HARTRANFT. Mayor of Philadelphia–WILLIAM S. STOKLEY.

COMMISSIONERS FOR THE ERECTION OF THE PUBLIC BUILDINGS
JOHN McARTHUR, JR. ARCHITECT.　　Act of Assembly, August 5, 1870.　　SUPERINTENDENT –WILLIAM C. McPHERSON.
PRESIDENT – SAMUEL C. PERKINS.

THOS. J. BARGER, SAMUEL W. CATTELL, MAHLON H. DICKINSON, THOS. E. GASKILL, JOHN L. HILL, RICHARD PELTZ, WILLIAM BRICE, LEWIS C. CASSIDY, ROBT. W. DOWNING, A. WILSON HENSZEY, HIRAM MILLER, WM. S. STOKLEY, SECRETARY – FRANCIS DE HAES JANVIER. TREASURER – PETER A. B. WIDENER. SOLICITOR – CHARLES H. T. COLLIS.

Three years after construction on the building had begun, the cornerstone was laid with much pageantry on July 4, 1874. Architect McArthur and chairman of the building commission Samuel Perkins were prominently mentioned; however, Alexander Milne Calder, who had only recently been hired to contribute a sculptural program to the effort, went unmentioned and unrecognized.

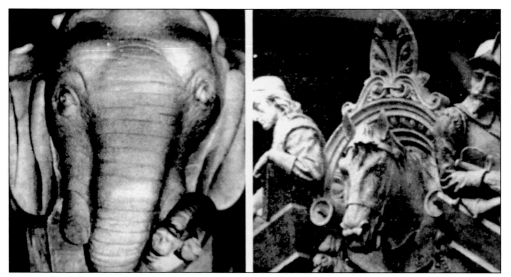

Many of Calder's artistic creations were members of the animal world. These photographs of an elephant, lion, horse, and owl were just part of the large menagerie displayed on the building. Also captured in artistic reliefs were beavers, mice, frogs, tigers, camels, sheep, buffalo, bears, goats, seals, bulls, eagles, and moose.

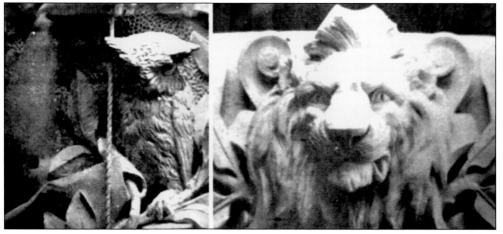

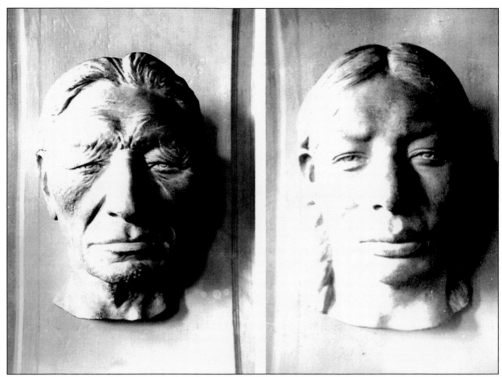

One of the more surprising aspects of Calder's sculptural program was the absence of portraits of such national heroes as Lincoln, Grant, and Washington. Although the Civil War had only recently ended, conventional historic personages were almost entirely banished from the building. Themes adopted tended to be Biblical, classical, or freely invented allegory.

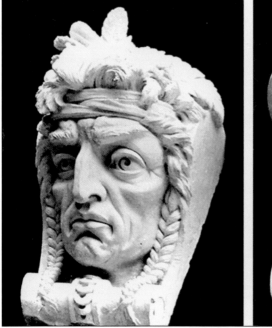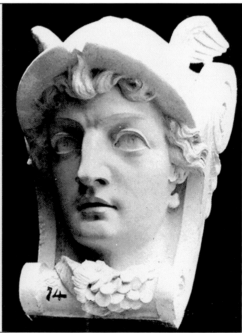

Over the west portal, where the prison vans entered the courtyard, Calder placed sculptures of Sympathy and Repentance. Figures of Prayer and Meditation were central to the allegorical display, and one spandrel depicts the prodigal son asking for forgiveness.

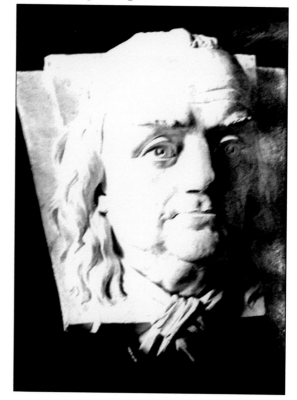

Calder's sculpture of Benjamin Franklin was placed over the east portal of city hall as a testament to this great American and his symbolic representation of the old Philadelphia. Franklin was one of only three Philadelphians to be honored with his image on the building. The other two were Penn, the founder of the colony, and Horace Binney, a great 19th-century jurist.

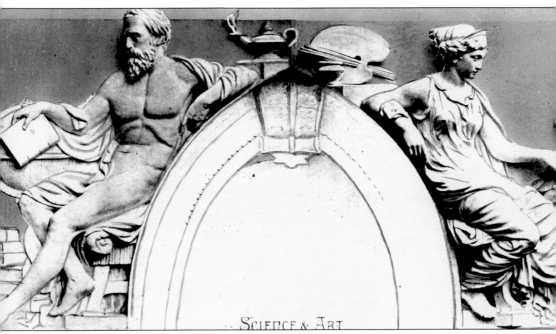

SCIENCE & ART

Over the east entrance of city hall is the face of Benjamin Franklin and the seated figures of Industry and Peace. The spandrel reliefs showcase the figures of Art and Science, creative attributes belonging to the citizens of Penn's colony.

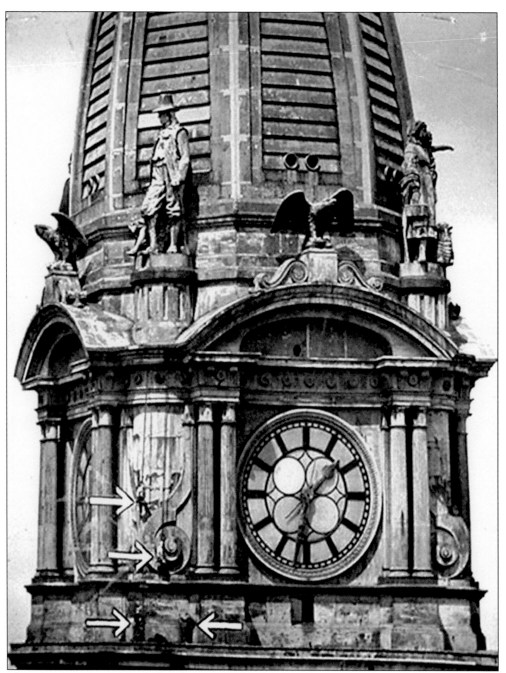

This photograph of the south side of the city hall clock tower shows a Swedish pioneer, his wife, and his child. The positioning of the figures was symbolic of the early Swedish explorers who settled along the Delaware River, south of the city. Native Americans were placed on the north side of the tower symbolizing Pennsylvania's reach to the north and west, and the fact that Penn was said to have made peace with Native Americans at Penn Treaty Park.

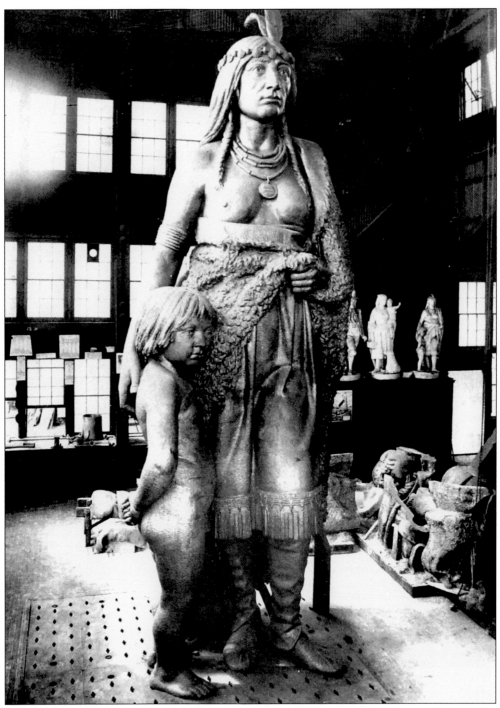

Among the first occupants of city hall were Alexander Calder and his assistants. Clay models, plaster casts, and metal sculptures took over one section of the ground floor as his assistants, James G.C. Hamilton and John Cassani, labored to fulfill the extensive complement of bronze and stone images for the building. It is believed that Calder's son, Stirling, was occasionally used as a model for the project.

The north portal was the main ceremonial entrance to city hall. The most ornate of the four portals, the elegant entranceway once led to the chambers of the select and common councils. Conversation Hall, the common meeting room of the two legislative bodies, was reached by climbing a grand staircase on each side of the portal.

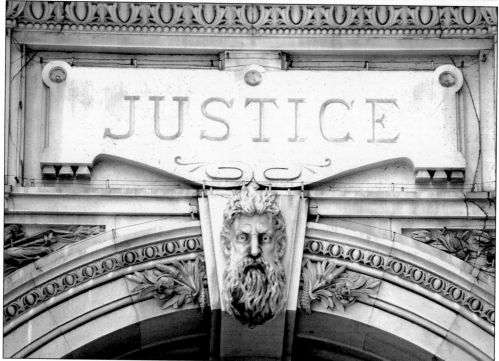

The head of Moses, the law giver, and the word "Justice" were strategically placed by McArthur over the arch of the south portal of city hall, as the entire southern section of the building was devoted to the courts and the dispensation of justice.

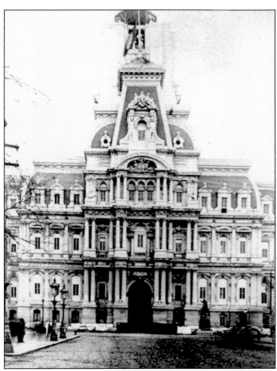

The north pavilion under the base of the tower showcased the history of Philadelphia and Pennsylvania. Above the portal is a keystone portrait of Penn flanked by figures depicting the conquest of the state: a Native American and a Swedish settler with an axe, which some believe represent barbarism and civilization.

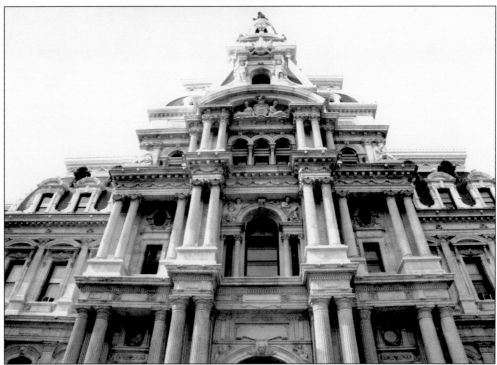

As the base of the city hall tower, the north portal was the ceremonial entranceway to McArthur and Calder's grand structure. A likeness of William Penn graces the overhead archway, as does the 37-foot, 27-ton statue of Penn 500 feet above the ground floor.

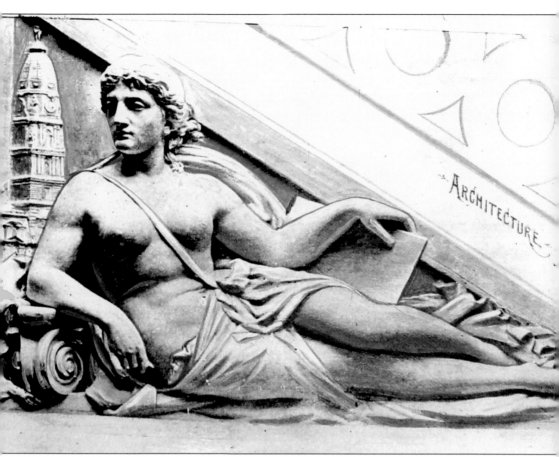

Along one wall in the east portal is the figure of a reclining woman with a sketchpad, Architecture. Over her shoulder, Calder placed the image of a fully completed city hall. For many years, unfortunately, the image was hidden by a commercial business that had taken up shop in the portal.

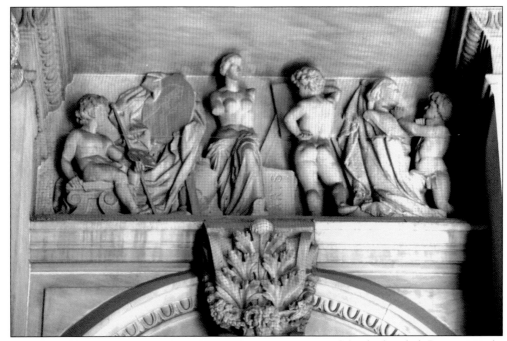

Portal alcove sculpture throughout the building is intricate and finely detailed. Remote nooks and out-of-the-way places seeming devoid of importance are graced with beautiful pieces of sculpture. The netting in front is a preventative device to inhibit the sculpture's attractiveness to pigeons and starlings.

The attention to detail of columns, capitals, and sculpture in the north portal was impressive. Because it was the main, or ceremonial, entranceway into city hall, McArthur and Calder made sure that only the finest marble, granite, and bronze figures were used.

No detail was too small or too incidental for the attention of the architect or sculpture. This photograph of a simple metal hose fixture in the south portal confirms the lengths taken to dramatize the smallest details. The heads of mythological animals were often used as creative devices for mundane fixtures.

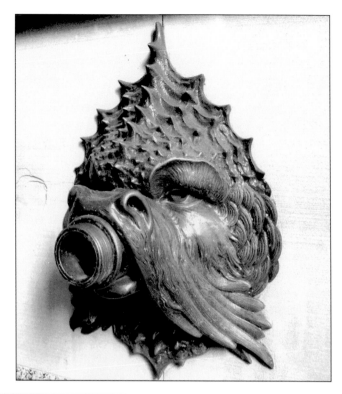

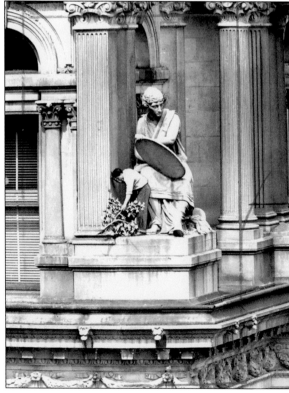

Many of Calder's statues were enormous. This photograph, showing a workman cleaning debris from one of the building's statues, graphically shows the enormity of some of the 94 freestanding statues on city hall.

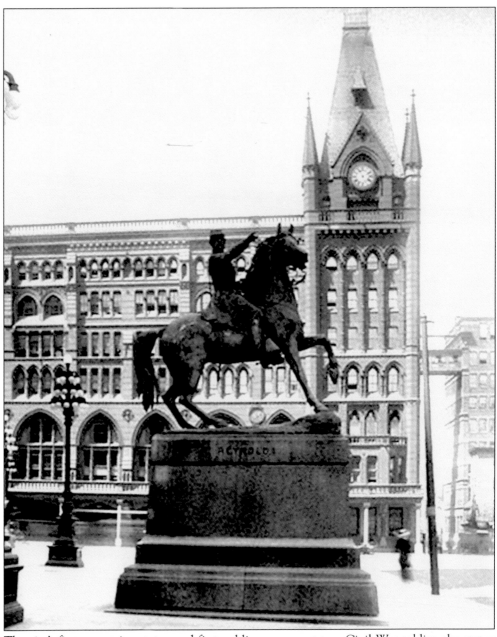

The city's first equestrian statue and first public monument to a Civil War soldier, the statue of Gen. John F. Reynolds, who lost his life at Gettysburg, was erected on Grand Army Day in 1884. The scene captures General Reynolds directing his troops on the first day of battle at Gettysburg. Sculptor John Rodgers, a popular Victorian-era sculptor, used three and a half tons of bronze on the statue.

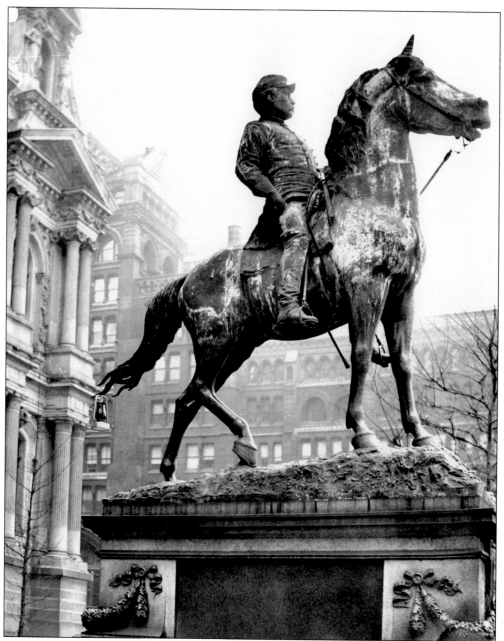

City hall's impressive sculptural facade was complemented by a number of handsome sculptures on the building's apron. The bronze statue by Henry Jackson Ellicott of the Civil War general George B. McClellan, the hero of Antietam, was erected near the north portal in 1894.

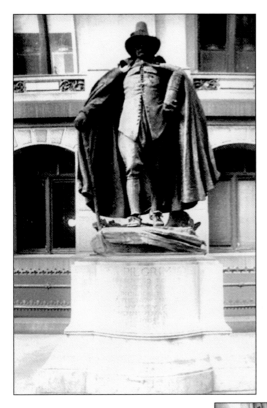

The Pilgrim, by Augustus Saint-Gaudens, currently resides on East River Drive at Boat House Row. It was originally placed on city hall's south plaza in 1905. The statue was a gift by the New England Society of Pennsylvania. Saint-Gaudens used an earlier work of a Puritan deacon as a model for his Philadelphia subject. The statue was moved to East River Drive in 1920.

This statue of John Christian Bullitt, framer of the Bullitt Act, which created an early city charter, was sculpted by John J. Boyle and placed on city hall's north plaza in 1907. A noted stone carver and fellow student of Thomas Eakins, Boyle was one of America's leading sculptors *c.* 1900.

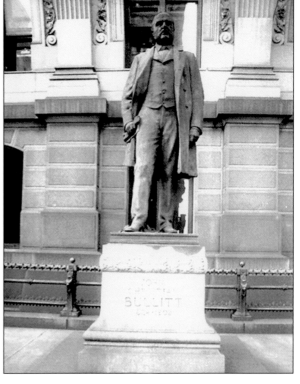

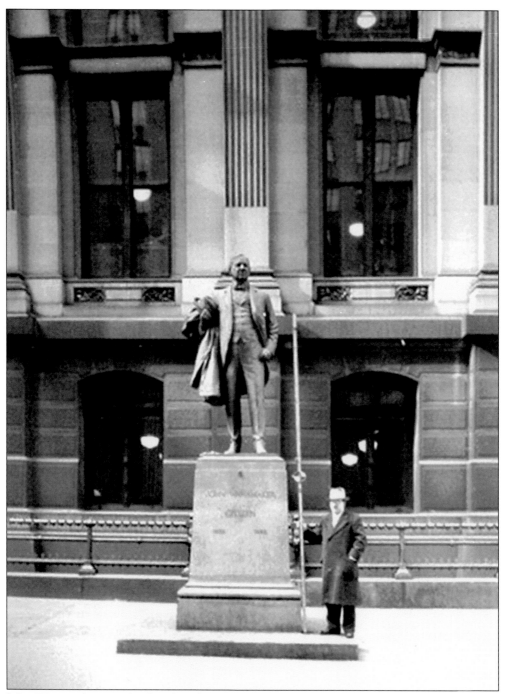

John Wanamaker was the founder of the famous Center City department store that sat just to the east of city hall. His statue was noted for being the cleanest of the many statues on the city hall apron. While others such as McClellan and Reynolds grew dark and corroded from the accumulation of dirt and grime over the years, Wanamaker remained immaculate and dirt free. The reason was that employees of the store were regularly assigned the task of cleaning grime and bird droppings off of the old entrepreneur.

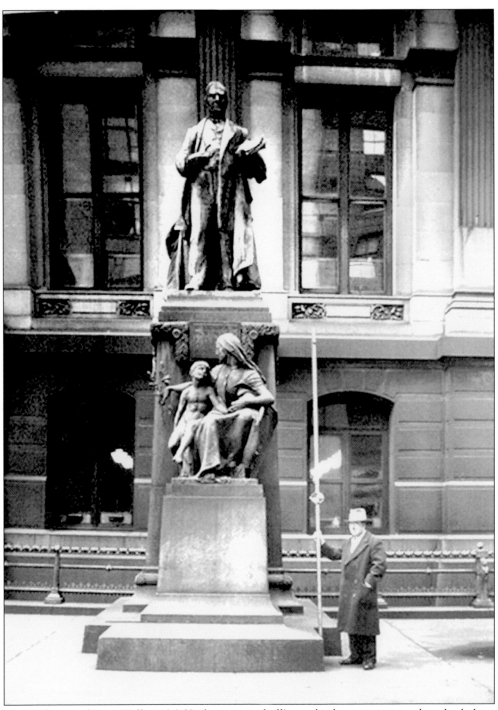

The sculpture of Pres. William McKinley on city hall's south plaza was initiated at the behest of the *Philadelphia Inquirer* to honor his memory after his assassination in 1901. Charles Albert Lopez was the sculptor, but Lopez's death in 1906 forced Isidore Konti to complete the work. Below the characteristic pose of McKinley, the orator, is the symbolic figure of Wisdom instructing Youth.

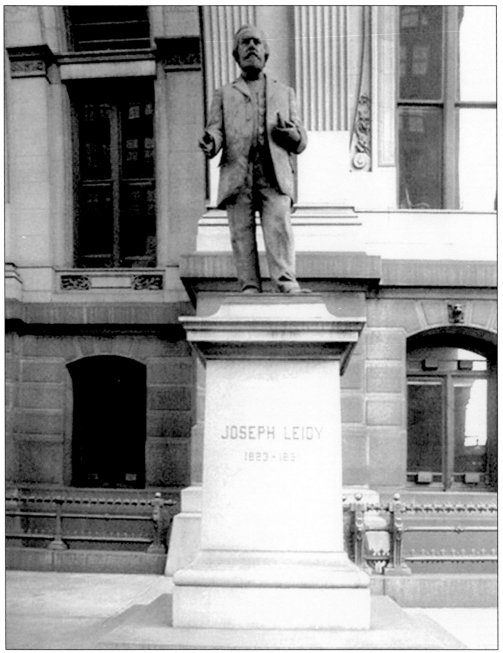

This statue of Joseph Leidy resided at city hall from 1907 until 1929, when it was moved to its present site at the Academy of Natural Sciences. The sculptor, Samuel Murray, was a Philadelphian who trained with Thomas Eakins at the Pennsylvania Academy of Fine Arts. Murray was also the sculptor of the statue of Commo. John Barry at Independence Hall as well as the Pennsylvania Monument at Gettysburg.

ERECTED BY
THE ALUMNI OF GIRARD COLLEGE
AND
THE PEOPLE
OF THIS
CITY AND COMMONWEALTH
1897

Though McArthur and Calder's artistic works were ideally designed to be admired and treasured by passersby, some local residents found more practical reasons to appreciate the artwork. Here, a citizen is caught taking a catnap along Philadelphia City Hall plaza and using a piece of equestrian sculpture as his own private lounge chair.

Over the last century, city hall has often required a good cleaning. Due to severe budget constraints, these housekeeping chores have been few and far between, resulting in the building and its sculptural accouterments showing more than their fair share of wear and grime. The building's enormous size and several hundred pieces of sculpture have no doubt complicated the problem. These photographs show one of city hall's equestrian statues receiving much-needed attention.

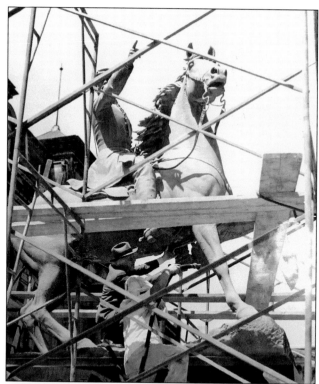

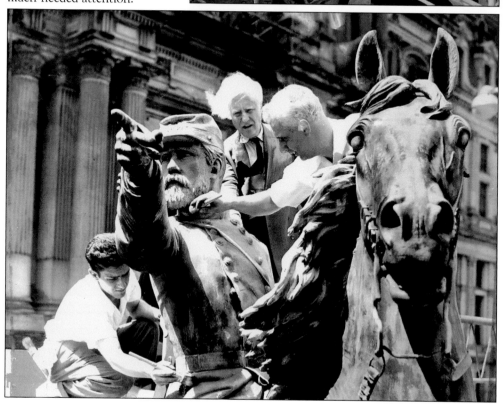

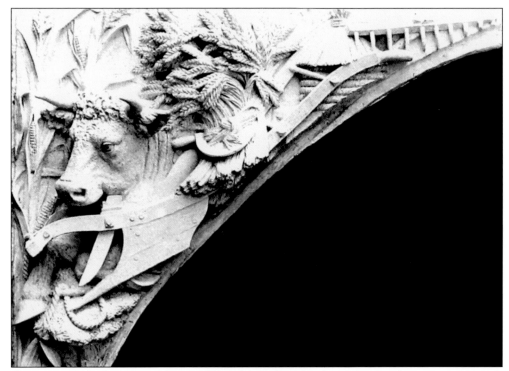

Corner panels display unique aspects of Philadelphia's geography, such as its close association with both the sea and the land. Nautical instruments and agricultural tools underscore the necessary implements that helped the early settlers survive their initial years in the new colony.

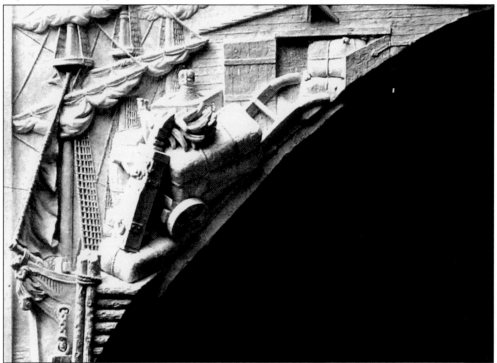

Four

THE INTERIOR

Although the cost of the construction of Philadelphia's new public buildings, or city hall, escalated by over twofold during its 30-year evolution, not all of those millions went for William Struthers's masonry and Alexander Calder's sculpture. A healthy portion of it went into decorating some of what would be viewed as "the grandest and most completely appointed suite of rooms . . . in the Union."

Some of the rooms and meeting places, including Conversation Hall, the mayor's reception room, and city council chambers, were as stylish and richly decorated as rooms found in a king's court. In fact, when Mayor Charles Warwick first entered his office in 1897, newspapers commented that his office was "an elegant apartment fit to receive any foreign potentate who may in the future visit the city." Moreover, "visitors from this and other countries will be almost transfixed by their splendor."

A century can take its toll on a structure—both externally and internally—so there is no doubt that some of the original splendor of the building has somewhat diminished over the years. However, while there are new dropped ceilings, new lighting, and faux-wood paneling in some rooms, many of the most important rooms remain as they did at the turn of the last century. Multicolored mosaic floors covered with rich Oriental rugs, fancy ornamental ceilings tinged with aluminum leaf, various colored granite walls accented with relief sculptured heads, majestic eye-catching chandeliers, large fireplaces with grand mahogany mantels, and finely hand-carved wood furniture still showcase the striking intent of the buildings designers.

Plush facilities and living accouterments, however, are not the only thing that distinguishes the interior of city hall. In addition to handsome courtrooms and lavish legal and legislative offices were some noteworthy and innovative architectural designs such as the "flying staircases," which spiral upward from the ground to the sixth floor at each of the corner pavilions. Described at the time of their construction as "marvels of architectural skill," the cantilevered staircases conceived of by Thomas Ustick Walter were said to be the "finest hanging stairways in the world." Some observers were even known to become lightheaded by just the sight of them. Alas, city hall was an architectural masterpiece—both inside and out.

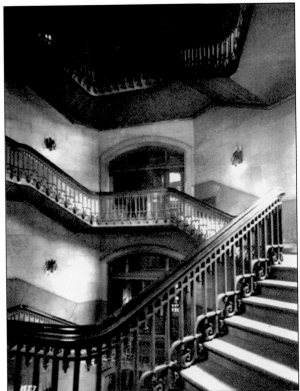

The spacious spiral staircases at each corner of the building incorporated unusual architectural features. Carved from Cape Ann granite, the steps extended out from the stairwell wall and climbed five stories skyward without any visible means of support. These "hanging stairs" were uniquely anchored into the wall with each granite slab or step firmly resting on the one below it. Many first-time visitors to the building were captivated—and sometimes frightened—by the cantilevered steps, but they have remained true and firm for over a century of continuous use.

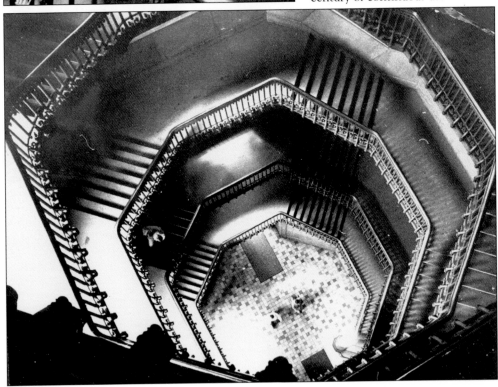

One of the most attractive and elegant rooms in city hall was the mayor's reception room. Described at the time as an "elegant apartment fit to receive any foreign potentate," the "Grecian" designed room had two Ionic columns, a grand fireplace in green marble, and much strategically placed mahogany throughout. It has usually been used for special occasions and press conferences, but for a short time early in its history mayors used the reception room as their main working office. In recent years, the room has been graced with the portraits of past mayors and a large portrait of Penn.

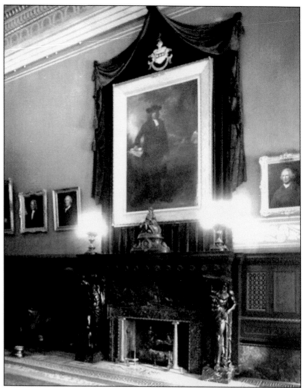

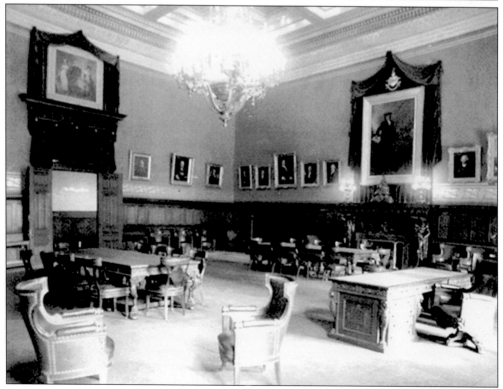

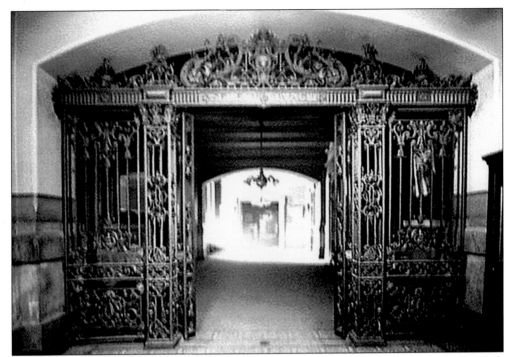

This ornate iron gate notified citizenry they were about to enter Philadelphia City Council. The county's legislative body utilized large parts of the building's fourth and fifth floors. In addition to council members' offices were a large caucus room, committee rooms, and a lavish council chamber where public business was heard.

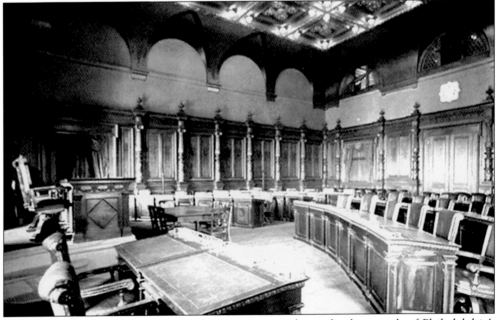

Offices of elected officials were spared no expense, as this early photograph of Philadelphia's city council's finance committee chambers demonstrates. Hand-carved dark mahogany chairs, desks, and walls once graced many of the rooms in the building.

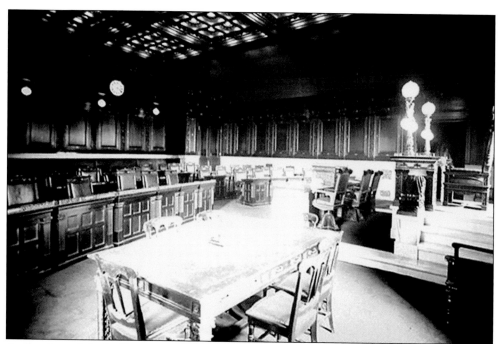

At the time of city hall's construction, the city of Philadelphia had a bicameral legislative body with a select and common council. Seen here are the select council chambers (above) and the common council chambers (below). With the adoption of a new city charter in 1919, the bodies were merged into one city council and the former common council chambers were used as the council chamber. The former select council chamber was transformed into the clerk of courts office. Both council chambers had elaborate columns, pilasters, cornices, wainscoting, and gallery railings covered with white Alabama marble. The chambers' walls, ceilings, and furniture were made of the finest materials and displayed intricate designs.

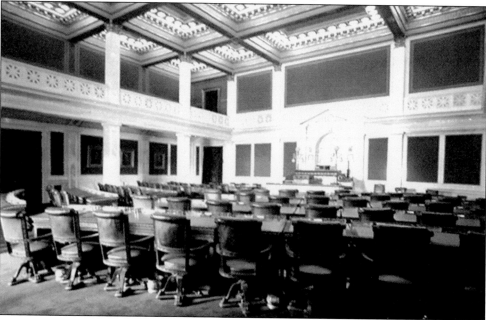

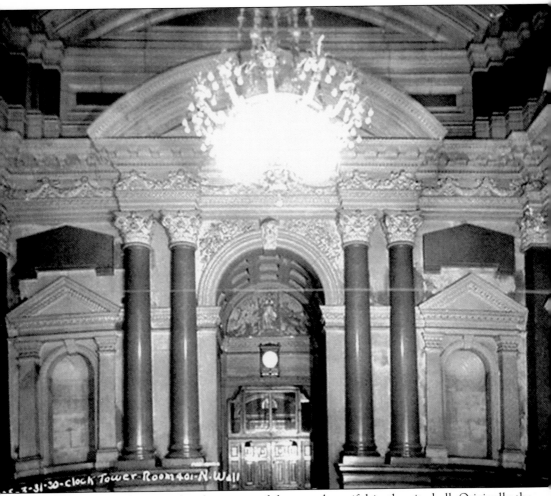

CC-3-31-30-Clock Tower-Room 401-N.Wall

The city council caucus chamber is one of the most beautiful in the city hall. Originally the upper portion of the five-story Conversation Hall, the vast space had to be redesigned when cracks appeared in the walls. To shore up the great weight of the tower, additional granite blocks were added to the walls with new floors for greater support. A large chandelier, huge circular table, domed ceiling, and marble columns are just a few of the many amenities of this magnificent room.

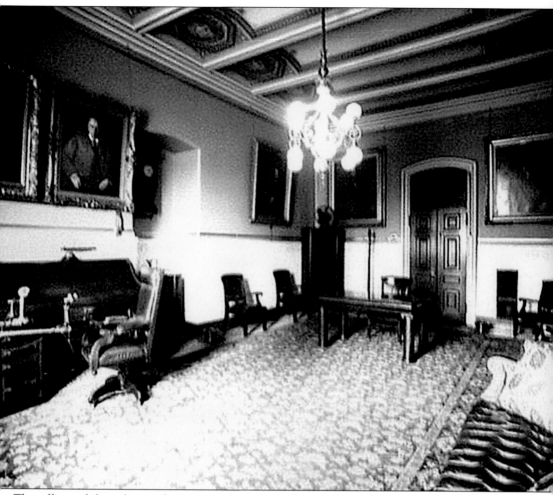

The offices of the select and common council presidents were well appointed, if not lavish. The leaders of each legislative body had considerable power and influence, and their respective offices usually displayed it.

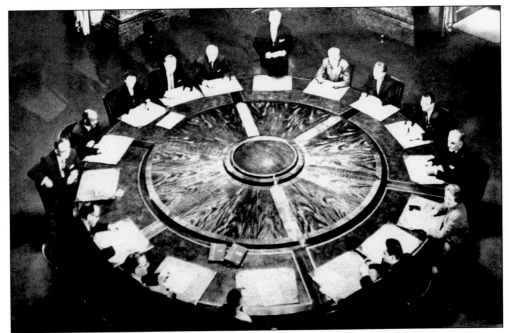

The fourth-floor city council caucus room is a beautiful marbleized structure with impressive columns and an ornate ceiling. One of the most eye-catching aspects of the room is a huge circular wooden table that all 17 council members sit at to discuss topical issues before their regular Thursday council sessions.

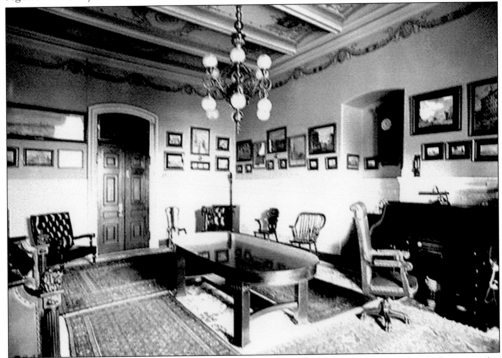

This photograph shows the well-appointed office of the president of city council. Prior to the 1919 charter change, there were two legislative bodies; therefore, there were two presidents.

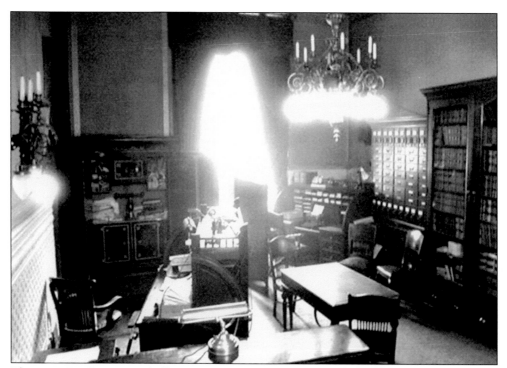

The mayor's office in city hall was a warren of both large and small offices. This photograph shows a typical section of the mayor's office as it existed during the early 20th century.

For many a decade, city hall was home to the Philadelphia Police Department. Among the many administrative units housed in the building was the police dispatcher's office that is captured in this photograph. The construction of the "Roundhouse" on Vine Street allowed this growing department to finally find more suitable quarters.

City hall was home to the Philadelphia District Attorney's office and most other city departments for many decades. This 1954 photograph shows the district attorney's law library as it existed in the mid-1950s.

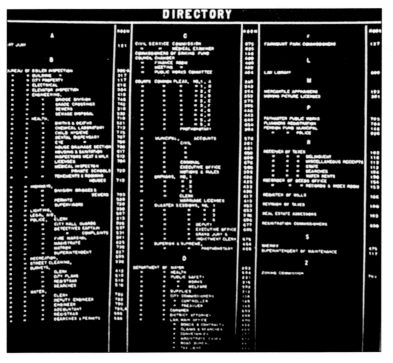

For most of its history, city hall directory was a blizzard of choices, offices, and individuals. In a building with nearly 700 rooms and the seat of government operations, citizens could find everything from the office of child hygiene and the police matron to the inspector of nuisances and the city commissioner of ice boats.

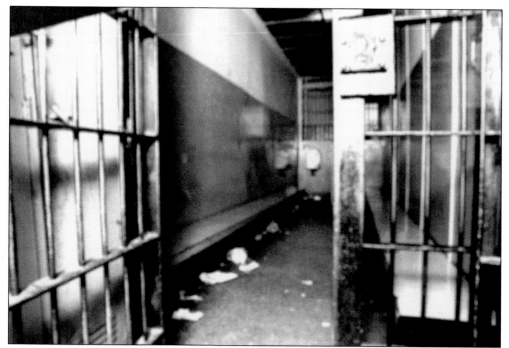

For the several hundred unfortunate souls brought to the seventh-floor cell room each day for trial, city hall was a hot, congested, foul-smelling prison. Although improvements were periodically undertaken, several glass and steel enclosed holding tanks containing 50 or 60 defendants were thought by many to be worse than prison itself. At one time, prisoners received hot meals for lunch. Cost-cutting measures resulted in bologna sandwiches being substituted for the hot meals in the 1980s. Given to inmates when they arrived at 8 a.m., they were usually eaten or stolen before the hour was out.

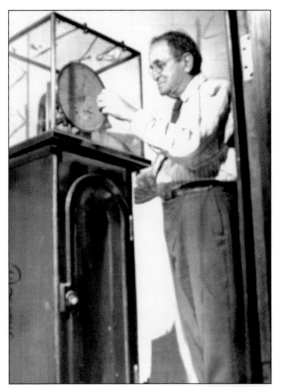

Joe Gaskill and his intricate city hall master clock were inseparable companions for decades. From the clock's first tick on December 31, 1898, until well into the 1930s, Joe Gaskill ensured that area-wide residents would have the correct time when they gazed upon the clock.

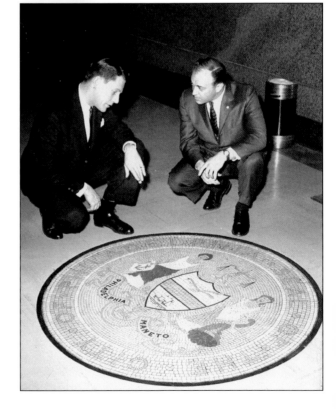

Intricately placed pieces of tile woven into the floor outside the mayor's office showcase the city seal. The figures on the shield symbolize Philadelphia's strong ties to both sea and land, as shipping and agriculture were keystones of commerce and life in Colonial Philadelphia.

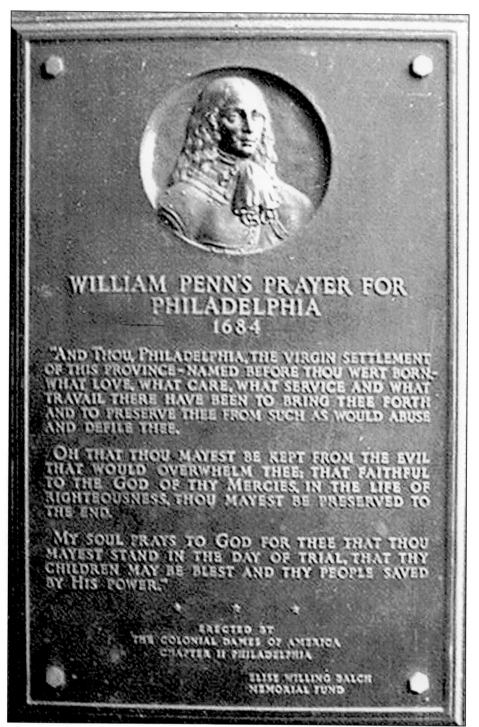

WILLIAM PENN'S PRAYER FOR
PHILADELPHIA
1684

"AND THOU, PHILADELPHIA, THE VIRGIN SETTLEMENT
OF THIS PROVINCE - NAMED BEFORE THOU WERT BORN-
WHAT LOVE, WHAT CARE, WHAT SERVICE AND WHAT
TRAVAIL THERE HAVE BEEN TO BRING THEE FORTH
AND TO PRESERVE THEE FROM SUCH AS WOULD ABUSE
AND DEFILE THEE.

OH THAT THOU MAYEST BE KEPT FROM THE EVIL
THAT WOULD OVERWHELM THEE; THAT FAITHFUL
TO THE GOD OF THY MERCIES, IN THE LIFE OF
RIGHTEOUSNESS, THOU MAYEST BE PRESERVED TO
THE END.

MY SOUL PRAYS TO GOD FOR THEE THAT THOU
MAYEST STAND IN THE DAY OF TRIAL, THAT THY
CHILDREN MAY BE BLEST AND THY PEOPLE SAVED
BY HIS POWER."

ERECTED BY
THE COLONIAL DAMES OF AMERICA
CHAPTER II PHILADELPHIA

ELISE WILLING BALCH
MEMORIAL FUND

The bronze tablet erected inside the North Broad Street entrance of city hall by the Friends' Historical Society is Penn's 1684 "Prayer for the City." Penn wrote the document aboard a ship on the Delaware prior to returning to England and requested that "his final prayer for his Holy Experiment be generally circulated" among the people of the city.

With nearly 700 rooms and a multitude of nooks and crannies to hide in, city hall became a daily hiding place for a vast array of fowl, cats, and humans looking for a temporary place of escape. This 1933 photograph shows children on the run being escorted out of their home in the rafters of the building's basement and subbasement.

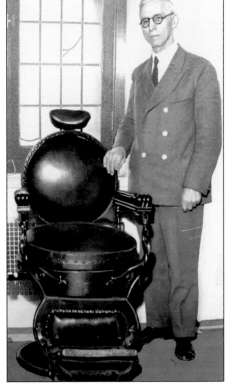

One of the stranger artifacts to be seen in city hall during the Depression years was a professional barber's chair. Located in the city solicitor's office, the chair signified an unusual governmental service—haircuts—that were freely dispensed. There is no word as to whether the barber was on the city payroll.

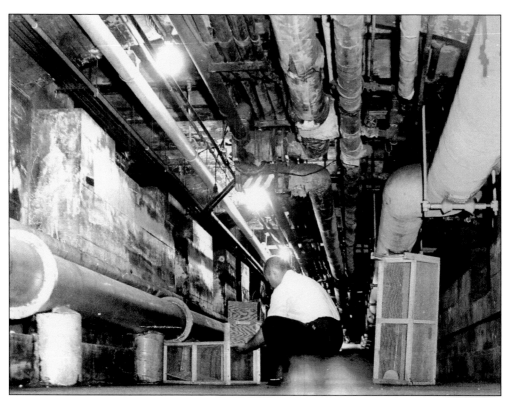

Over the years, city hall has had to put up with some pretty pesky two- and four-legged creatures. During the mid-1900s, wild felines became a serious problem necessitating the construction of numerous traps. These photographs show workers setting traps for the 70-some wild cats that set up shop in the building's subbasements.

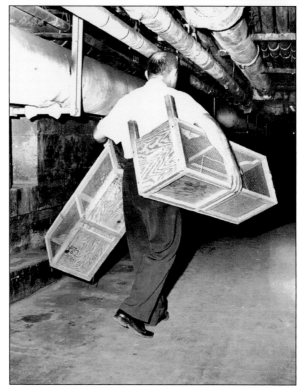

Courtrooms of every size and variety were situated throughout city hall. Some were extremely large and could comfortably hold several hundred spectators. Others were considerably smaller and only provided a row or two of chairs for interested observers.

In the upper reaches of city hall was room 975, a city property room that was used for a number of different functions. This 1947 photograph shows the large room set up as a classroom, possibly for new city employees. The room is currently used for storage.

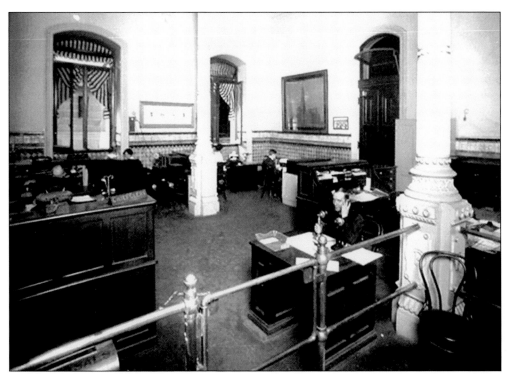

Room 113 on the first floor was another multipurpose city property room. Official photographers for city hall currently use this room.

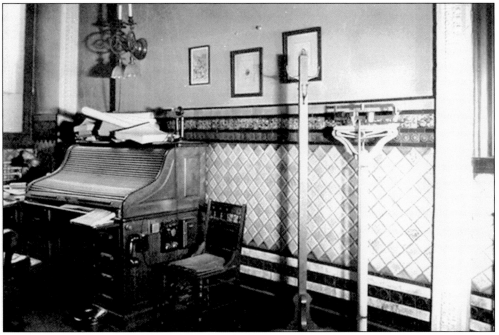

As the hub for all municipal activity in the county, city hall had to make room for offices dealing with everything from house drainage to juvenile delinquency. Room 127 on the ground floor of the building, shown in this photograph, was the office of the commissioner for public parks.

Although the offices of the mayor, council presidents, and various city commissioners could be lavish indeed, offices for most city hall employees were far less ornate and ostentatious. This photograph of room 119 shows a typical municipal office in the early 1900s.

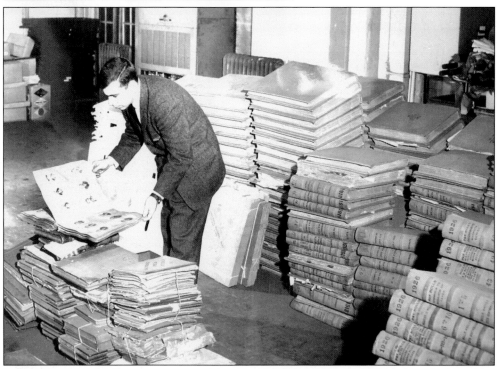

City hall's enormous floor space—over 14 acres—served numerous municipal needs, including the storage of valuable papers, documents, and artifacts. This photograph shows a researcher in city hall archives, once located in the building's basement, examining mug shots of 19th-century criminals.

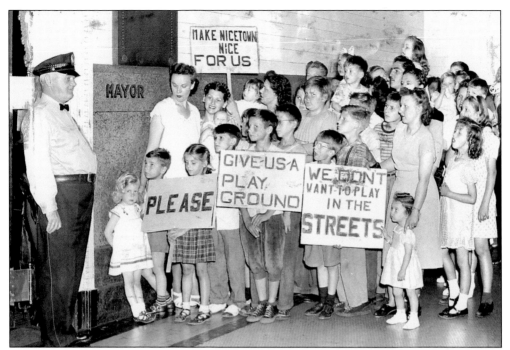

Throughout its history, city hall has been the epicenter of disgruntled Philadelphians advocating in favor of a particular legislative measure or organizing in opposition to an unpopular political initiative. Protests and demonstrations outside the mayor's second-floor office and city council chambers on the fourth floor have become commonplace. The photograph above shows children and their mothers requesting more playgrounds in the 1940s. The photograph below is a protest by schoolchildren and their mothers organized to block the closure of several neighborhood schools in 1981.

BIBLIOGRAPHY

Campbell, Lawrence M. "The Great Stone Zoo." *The Sunday Bulletin Magazine* (October 24, 1965).

Greenberger, Greta, and Noel Miles. *The Splendors of Philadelphia's City Hall: an Artist's View*. Philadelphia: Fund for Philadelphia, 2002.

Gurney, George. "The Sculpture of City Hall." In *Sculpture of a City: Philadelphia's Treasures in Bronze and Stone*. New York: Walker Publishing, 1974.

Gurney, George. "William Penn." In *Sculpture of a City: Philadelphia's Treasures in Bronze and Stone*. New York: Walker Publishing, 1974.

Lewis, Michael J. "Silent, Weird, Beautiful: Philadelphia City Hall." In *19th Century, Victorian Society*. Vol. 11, nos. 3 and 4, 1992.

McCarthy, Michael P. "The Unhappy Tale of Building Philadelphia's City Hall."

Page, Max. "From 'Miserable Dens' to the 'Marble Monster:' Historical Memory and the Design of Courthouses in Nineteenth-Century Philadelphia." In *The Pennsylvania Magazine of History and Biography*, no. 4 (October 1995): 119.

Of the scores of newspaper articles from the *Philadelphia Evening Bulletin* that were examined, some of the more helpful included:

"City Hall Site Chosen in 1870 After Hot Fight." (January 20, 1924).

"City Hall Statues to Walk." (April 30, 1936).

"The Face that's Launched a Million Dates." (May 19, 1933).

"Fry, Harrison, Horses, Hangings and Whoopee in Old Center Square." (December 16, 1939).

"Lee, Laura, City Hall Cannon Recite Their Woes." (May 23, 1936).

"Lee, Laura, City Hall Plaza Orators Win Listeners Nearly Every Day." (October 17, 1931).

"Many Men's Blood." (1896).

"Penn Garb Wrong, Says Historian." (January 22, 1924).

"Sculptor of Penn Statue Dies at 77." (June 14, 1923).

"Sculptor of William Penn Statue Died Disappointed at Position." (May 13, 1947).